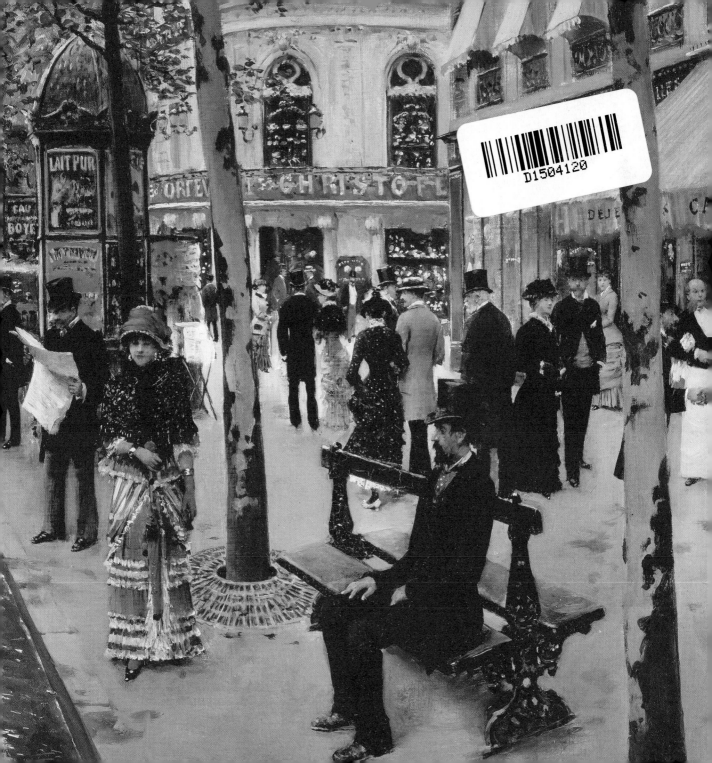

Women Walking

WOMEN
WALKING

FREEDOM · ADVENTURE · INDEPENDENCE

Karin Sagner

Abbeville Press Publishers

New York London

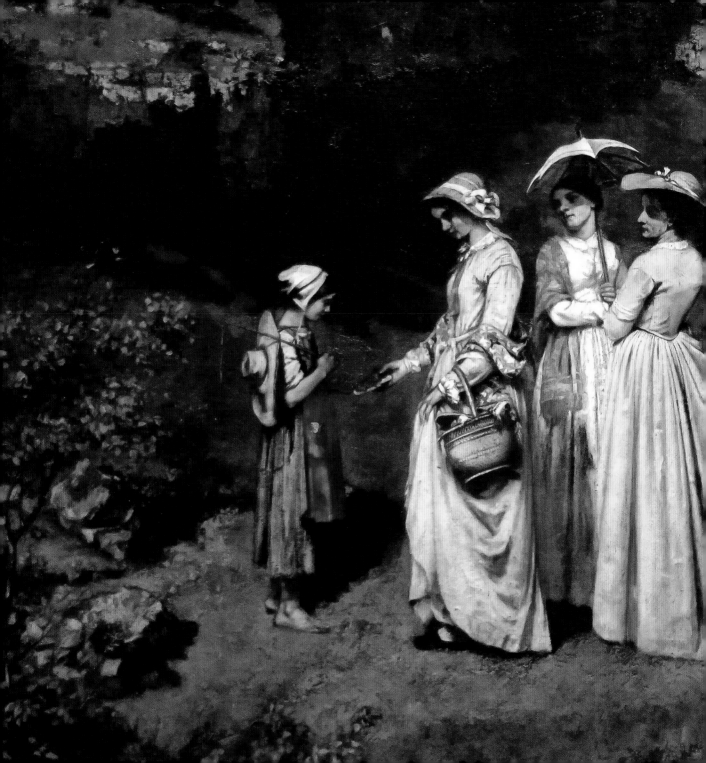

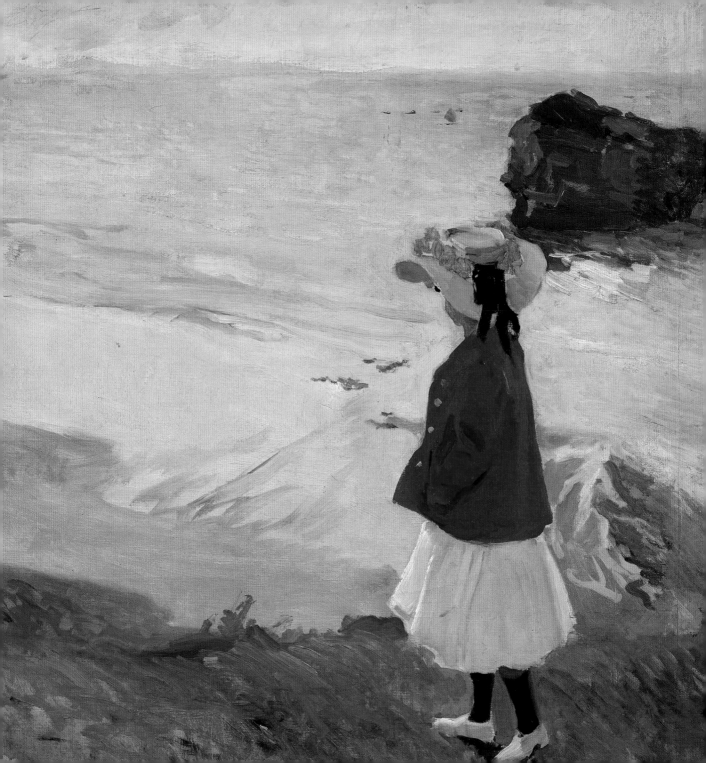

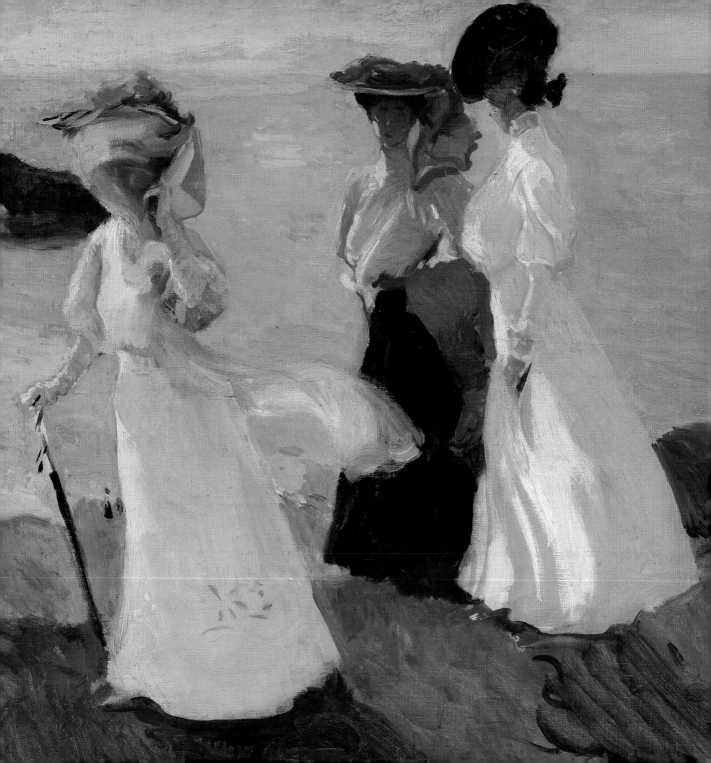

Translated from the German by Russell Stockman

For the Abbeville Press edition
Editor: Will Lach
Produciton manager: Louise Kurtz
Cover design: Misha Beletsky
Interior design: Julia Sedykh

This edition first published in the United States of America in 2017
by Abbeville Press, 116 West 23rd Street, New York, NY 10011

This book was first published in German by Elisabeth Sandmann
Verlag, Munich, under the title *Frauen auf eigenen Füssen: Spazieren,
Flanieren, Wandern* (2016).

First edition
10 9 8 7 6 5 4 3 2 1

ISBN 978-0-7892-1286-3

Library of Congress Cataloging-in-Publication Data available on
request.

For bulk and premium sales, write to Customer Service Manager,
Abbeville Press, 116 West 23rd Street, New York, NY 10011, or call
1-800-ARTBOOK

Visit Abbeville Press online at www.abbeville.com

Front cover, detail
Emilie Caroline Mundt
Lady in White Reading, 1901
(see p. 29)

Back cover, detail
Charles Wellington Furse
Diana of the Uplands, 1903/04
(see p. 114)

Front endpaper, detail
Jean Béraud, French, 1849–1936
Paris's Boulevard des Capucines with Female Pedestrian, ca. 1890
(see p. 74)

Back endpaper, detail
James Wallace, English, 1872–1911
Autumn Walk in Kensington Park, ca. 1900
(see p. 58)

Page 3, detail
Joaquin Sorolla y Bastida, Spanish,
1863–1923
Walk on the Beach, 1909
Oil on canvas, 80¾ × 78¾ in.
Madrid, Museo Sorolla

Pages 4–5, detail
Henri Evenepoel, Belgian, 1872–1899
Sunday Walk in the Bois de Boulogne, 1899
Oil on canvas, 75 × 118 in.
Liège, Musée d'Art Moderne et d'Art
Contemporain

Pages 6–7, detail
Gustave Courbet
Young Ladies of the Village, 1851–52
(see p. 123)

Pages 8–9, detail
Joaquin Sorolla y Bastida
Lighthouse Walk at Biarritz, 1906
(see p. 28)

Pages 10–11, detail
Ilya Yefimovich Repin
Summer Landscape, 1879
(see p. 95)

Pages 142–43, detail
Félix Vallotton
The Garden du Luxembourg (Walk), 1905
(see p. 63)

Pages 144–45, detail
Jean Béraud
Walk: The Pont Neuf in Paris, 1880/81
(see p. 65)

Pages 146–47, detail
Hans Andersen Brendekilde
Walk in Spring, 1903
(see p. 91)

Pages 148–49, detail
Thomas Gainsborough
The Mall in St. James's Park, ca. 1783
(see p. 34)

Pages 150–51, detail
Gustave Caillebotte
Pont de l'Europe, 1876
(see p. 71)

Page 152, detail
Charles Courtney Curran
Summer Clouds, 1917
(see p. 111)

Contents

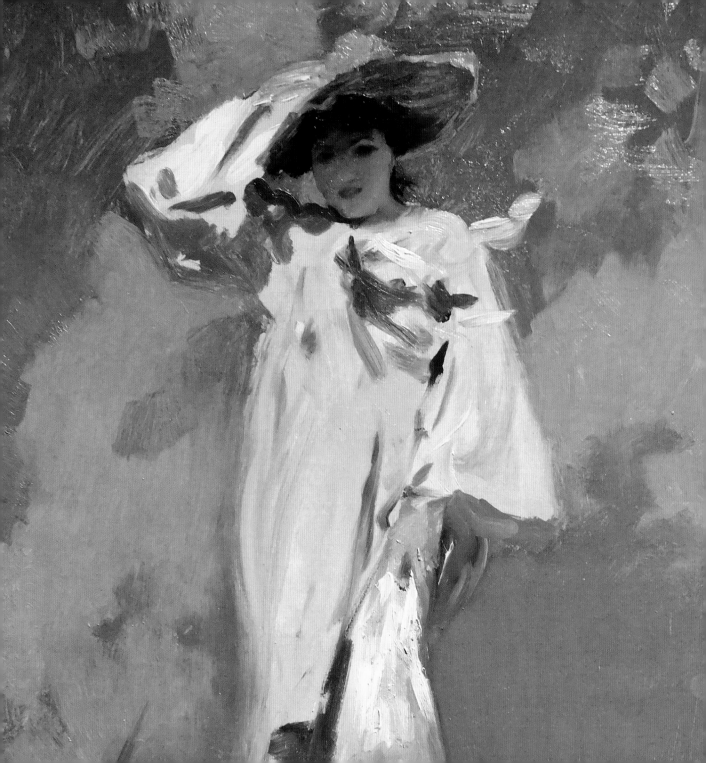

Women Walking

INTRODUCTION

John Singer Sargent, American, 1856–1925
A Gust of Wind (detail), 1887
Oil on canvas, 24¼ x 15 in.
Private collection

Round this island I wished to walk this summer, but no one would walk with me. It is the perfect way of moving if you want to see into the life of things. It is the one way of freedom.

Elizabeth von Arnim, British (b. Australia), 1866–1941

I n most situations, we take for granted that women are free to walk on
their own without worry, wander about the city, ramble about in na-
ture, or even climb mountains. Yet surprisingly, for a long time women
were permitted to venture out alone on foot to only a limited degree, even
as late as the beginning of the 20th century. Why was this so?

In this book, the history of women walking and hiking, mostly in Con-
tinental Europe, is told for the first time on the basis of works from the
fine arts and photography—most created by men—that reflect the male
view. Its special charm is the way these images are juxtaposed with liter-
ary excerpts—from novels, autobiographies, diaries—by self-confident
women about their love of walking.

There have always been courageous women, and so-called aimless ram-
bles and even mountain climbs by women are documented as early as the
sixteenth century, with the dawning of a new view of nature. Since they
are anomalous examples, however, they are not included in the present
publication. Nor does it discuss the participation of women (as compan-
ions and bearers) on pilgrimages.

The motif of the woman walker appears with particular frequency in
the literature and fine art from the late 18th through the late 19th century.
What made walking and hiking in general so significant in this period?
What role did women play in this new context? It is apparent that at first
strolling and promenading were activities largely limited to the aristocracy
and wealthy burghers. Outings (by coach or on foot) were part of the
daily routine, which after late rising, receiving and dealing with visitors,
enjoying the midday meal and writing letters, culminated in an evening of
theater and dancing. Pictures of courtly promenades in parks and gardens
accordingly appear quite early. There were fixed rules of behavior and dress
for courtiers strolling among extensive geometrical and strictly symmetri-
cal flower beds, trimmed hedges, pools, sculptures, and groomed stands

of trees. In such amusements the nobility, following the French example, was largely cut off from the outside world, turning to the outdoors for relaxation and refreshment, for contemplation and intimate encounters. In baroque gardens even noblewomen might walk alone, for in the form of a walled enclosure the garden had forever been seen as a refuge for women. Their obligatory daily stroll in the garden, where they might see and be seen, was simply a part of aristocratic life, and was considered confirmation of their social standing.

Beginning in the second half of the 18th century, the bourgeoisie increasingly took up the practice of the leisurely stroll as well, as parks and gardens became accessible to the public. Yet before and around 1800 it was still only a privileged minority that could flaunt its status by taking walks at any time of day. Encounters with common people were discouraged, and the entrances to grounds treasured by the aristocracy and wealthy upper classes were closely monitored. This was partly out of fear of having to witness vulgar behavior. It was reported that in English parks, for example, it was apparently not uncommon for men to relieve themselves within view of passing strollers, turning to face the shrubbery so as not to be recognized.

A new spirit gave rise in the years between roughly 1770 and 1830 to what writers of the period referred to as "sentimental walks," on which men and women might freely indulge in intellectual conversation. For now for the first time there were any number of full-time women writers like Sophie von La Roche, Johanna Schopenhauer, and Dorothea Schlegel who took up the subjects of walking and hiking with relish. In general, however, female promenaders were still confined to landscaped gardens or urban parks, and etiquette demanded that they be accompanied; Johanna Schopenhauer (1766–1838) remarked that "Promenading in public places . . . without a male escort is considered unseemly." Even so, bolder women dared to take longer solitary walks, selecting out-of-the-way footpaths through meadows, fields, and forests. And for women of the aristocracy and bourgeoisie, going beyond the socially accepted communal walk and Sunday stroll took particular courage. Women who routinely set out alone on foot belonged to the lower classes. For them, usually with only limited means, getting around on foot, even over longer distances, was an existential necessity. Yet unlike indigent men, they were subject to scorn or even accusations of prostitution. By contrast, noble and bourgeois women

Gabriel de Saint-Aubin, French, 1724–1780
Promenade in Longchamp (detail), ca. 1760
Oil on canvas, 31½ x 32¾ in.
Perpignan, Musée Hyacinthe Rigaud

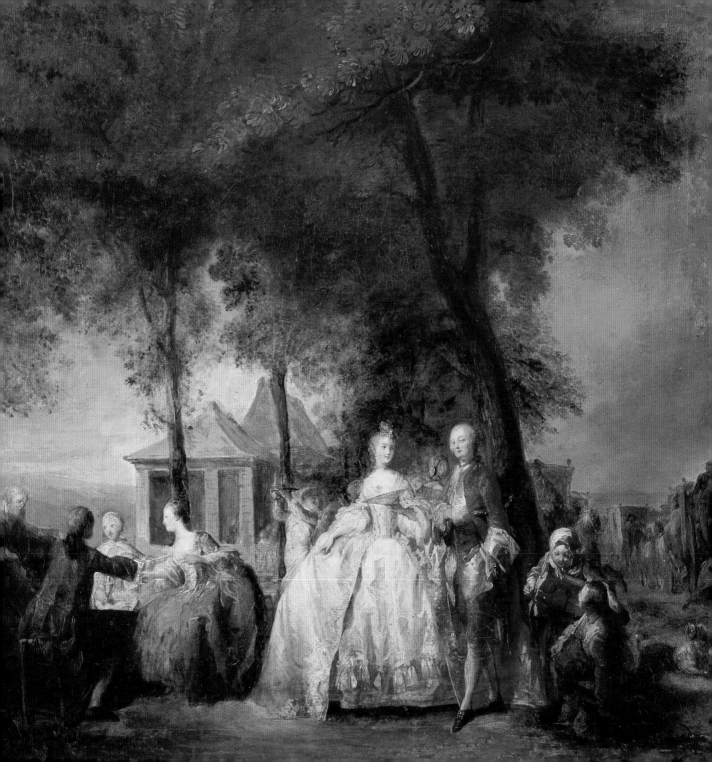

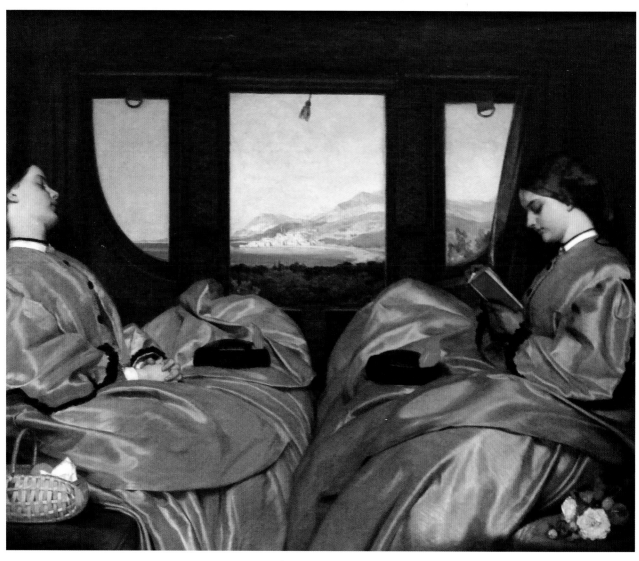

Augustus Leopold Egg, English, 1816–1863
The Traveling Companions, 1862
Oil on canvas, 25¾ × 31 in.
Birmingham Museum and Art Gallery

undertook longer journeys in the protective enclosure of coaches. The extent to which women's perception of the world was determined by what they saw looking out of coach windows was described in exemplary manner by Sophie von La Roche in her 1771 novel *The History of Lady Sophie Sternheim* (*Geschichte des Fräuleins von Sternheim*).

The restriction on women's mobility contrasted sharply with the freedom of movement encouraged among men. To the German writer and hiker Johann Gottfried Seume (1763–1810), walking was unquestionably a masculine option: "The man who walks sees . . . more than the one who rides. I consider voluntary walking a man's most honorable and independent activity . . . seated in a carriage one is removed from ordinary humanity. . . . Riding (in either a coach or a carriage) is indicative of impotence, walking of strength." Seume's view that choosing to walk as opposed to riding enhanced one's knowledge of the world dates from a time when coaching had become accessible to a larger segment of the populace, and moving about on foot was to some extent the exception. Yet it was essentially restricted to men, for walking—and this was the point—liberated a person from the confinement of urban housing by leading him into the openness of nature, providing physical exercise but also stimulating independent thought. To Enlightenment thinking the bourgeois walk thus proved to be an important symbolic act, critical of culture and society. For the duration of a walk in nature a man might turn his back on the feudal order and think of himself as a free agent, capable of standing on his own feet. The enlightened burgher was accordingly encouraged to undertake daily walks—better yet hikes—in all weathers.

In the 18th century, bourgeois women, increasingly relegated to the home, were given the same encouragement, but to only a limited degree. To be sure, enlightened writers recommended daily walks to strengthen women's bodies, even doing away with their confining corsets and the high-heeled shoes that made walking precarious, but this was primarily so that they might bear healthy children. Walking benefited their health, of great importance given their destiny as mothers. The subordination of women was no longer based on religion but on anthropology, which noted men's and women's different constitutions and the latter's relative physical "weakness." It is therefore easy to see that the notion of toughening the frail female body and psyche in line with Enlightenment theory led to such writings on the education of girls as Joachim Heinrich

Campe's (1746–1818) 1789 *Fatherly Advice for My Daughter* (*Väterlicher Rath für meine Tochter*), in which he recommended walking and hiking for strength as well as the morally beneficial occupation of the female sex with plants and nature.

Walks undertaken independently, and certainly solitary ones with relish, were undesirable, however, and considered damaging, as women could only enjoy nature in company with others. So until well into the nineteenth century female walkers generally continued to be chaperoned as the objects of bridal searches. As Johanna Schopenhauer confirmed: "Without being followed by a servant, or in the absence of one by her maid, no woman of the higher classes would have ventured (on foot) even the shortest distance along the street." So the bourgeois woman's range of movement remained limited, her walks confined to the familiar terrain of the surrounding, generally cultivated landscape.

This makes the testimony of women of the time who discovered the pleasures of walking and hiking in nature on their own all the more striking. They set their sights on a wider world, and made their way out into nature in order to enjoy its beauty. They were not so much moved to investigate it scientifically with Enlightenment curiosity, for as the emancipated early Romantic writer Dorothea Schlegel (1764–1839) relates in her novel *Florian*, methodical researches in untamed nature, Alpine rambles, even long-distance daylong hikes were transgressive and fraught with incalculable risks and dangers. It was considered reckless for a woman to walk in a forest or meadow with or without a male escort. This was in part because her physical and mental powers were supposedly insufficiently developed, her clothing too restrictive—as indeed it was—and also because to the Romantics the traversed landscape, as a reflection of one's own inner nature—risky for women—opened up possibilities for self-discovery. The mountain world was a man's domain. Mountains held all manner of terrors and dangers, even nightmarish situations to which the weaker sex was better not exposed. Even so, this did not prevent a few bold women from climbing mountains as early as the beginning of the 19th century. Their exploits were generally downplayed by male critics, and they were at first excluded from membership in the numerous Alpine societies founded after of the middle of the century.

Women who undertook long walks and mountain treks were even more likely to be accused of a loss of femininity than those who took solitary

walks close to home. They also ran the risk of possible sexual assault. Yet noblewomen, especially, deliberately broke with convention in climbing mountains, though at first accompanied by men, and in doing so demonstrated a new freedom. They experienced what Jean-Jacques Rousseau had celebrated in his 1782 *Confessions*: "Solitary walks [on which] we rambled from hill to hill and wood to wood, sometimes in the sun, but oftener in the shade, resting from time to time."

After the French Revolution and the declaration of citizens' and human rights, walking became a visible symbol of a general desire for freedom: fences fell, parks and palace gardens were opened to the public, and geometrical, carefully trimmed garden layouts were condemned as violations

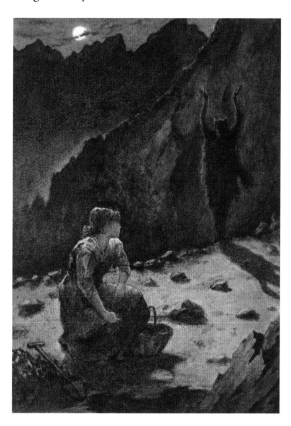

Philip Burne-Jones, English, 1861–1926
The Mountain Spirit, ca. 1870
Watercolor on paper, 8¼ × 5¾ in.
Private collection

of nature, replaced by expansive landscaped parks. In the 19th century, the innovative cultural practice of the bourgeois stroll solidified into a full-blown ideology of walking. Whereas in the preceding century rambles and hikes in open country were preferred, promenading and leisurely strolling were now the rage, with emphasis on amusement. One could say that the settings for walks shifted from unspoiled nature—fields, forests, meadows, shores, lakes, brooks, mountains, valleys—to a cultivated nature, to urban parks open to all: allées, boulevards, streets, squares.

This shift is directly associated with urban planning in the nineteenth century, in which hygienic issues grew in importance and urban green areas were set aside as buffers against the noise and pollution of early industrialization. Strolls in urban or suburban parks and gardens were supposed to provide the illusion of a stay in the country in natural surroundings. In addition, thanks to the slightly raised and dry sidewalks along boulevards and shopping streets—added in Paris beginning in mid century and imitated everywhere in Europe—for the first time it was possible to walk safely in one's city clothes. This gave rise to the figure of the flâneur so frequently described in literature, the man who on his aimless urban strolls simply takes in the changing scene. Like his virtually invisible female counterpart, the flâneuse, he was a product of urbanization and mercantilism. Both are depicted in art and literature in this context, though to a different degree.

But given 19th-century bourgeois conventions, women's freedom of movement outside the home was limited, unlike that of men. Walking on a street alone they risked social condemnation and even sexual assault, for without an attendant male they exhibited a want of status and could be suspected of being prostitutes. Well-bred women had no business being alone on Parisian boulevards with their coffeehouses, shops, and big-city bustle. The French writer Honoré de Balzac insisted that only women of dubious reputation strolled there, and that decent women might venture there only *en passant* for shopping and window-gazing. The boulevard was considered the province of the gregarious bourgeois male, whereas public gardens and parks provided "natural" outdoor space for women and children, and became favorite motifs for artists.

In fact it was only toward the end of the nineteenth century that it became possible for women to walk alone in urban spaces without having their virtue questioned. Female roles had been fixed within the bourgeois

Giuseppe De Nittis, Italian, 1846–1884
The Parfumerie Viollet on the Boulevard des Capucines, ca. 1880
Oil on canvas, 16 × 12¾ in.
Paris, Musée Carnavalet

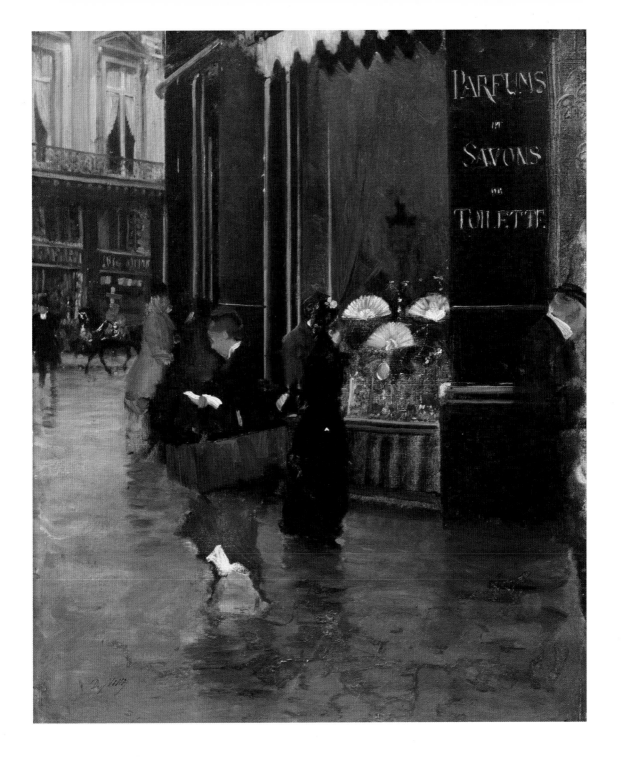

PARFUNS
ET
SAVONS
DE
TOILETTE

glorification of the family. Over the course of the century the family had become an ideal refuge, a completely independent world, morally superior to the public sphere. Yet beginning in mid-century this "idyll" was faced with a new threat—the emancipated woman. According to 19th-century bourgeois ideology, women's true vocation was serving as housewife and mother, maintaining the family's moral standards and sense of order. Such activities as reading and stepping outside on one's own were possible ways to escape social conventions. And in fact women's solitary walks and love of reading can be seen as the first sparks of their modern emancipation. But whereas the woman reading was a distinctly up-to-date motif in the art of the nineteenth century, especially in Impressionism, the woman walking alone or hiking in primeval nature remained largely undocumented.

Obviously spring and summer were the favored seasons for city walks and promenades, as they promised the greatest degree of comfort and pleasure. The chosen times of day varied from epoch to epoch; the morning walks of the 18th century were joined in the 19th by evening strolls in moonlight. Whereas in the 18th century it was still possible for the nobility to be seen walking any day of the week, in the waning 18th and early 19th centuries one came to encounter the urban bourgeoisie on Sundays and holidays, often after the midday meal, and at the end of the 19th century, once regulated working hours had been introduced, in the evening as well. Public promenades increasingly gave way to more intimate outings, while the Sunday family stroll played an ever greater role and was accordingly pictured by any number of artists. Also important by this time were walks along the seashore and beach, on lakeshore promenades, and at spas, all for their hygienic value as emphasized in the late 19th century's various reform movements.

Experiencing an outing in the fresh air together combined the positive values of recreation, pleasure, sociability, and nature. Astonishingly, in this context ladies might undertake walks quite alone without endangering their reputations. Such scenes are part of the artistic repertoire. As Honoré de Balzac explained in 1831 in his theory of walking and observations of the elegant life, in them fashion played a prominent role: "What indelible joy it is . . . to encounter in the streets of Paris, on the boulevards, those women who . . . know how to adapt to the modest role of a pedestrian, for they know how a pedestrian ought to dress." There were still clothing

restrictions for the various classes before the French Revolution, but ladies in the 19th century were subject to a universal fashion that had come into being with democracy. Accordingly, from the beginning the basic appointments of the female pedestrian included such accessories as the walking stick, in which perfume flasks might be hidden, the compulsory hat, gloves, and shawl, and a bag containing handwork, for a repectable lady was never to appear inactive.

And if she was in fact alone, up to the beginning of the 20th century she often carried with her an edifying book, in which she might become engrossed while walking. Nature thus became a backdrop to emotions inspired by literature. Or put another way, it was experienced and discovered through reading. No less popular since the 19th century were companion animals, preferably dogs on a long leash. If a woman was pictured accompanied by a family member, either they walked hand in hand, she was closely embraced (a motif already found in pictures from the 15th century), or they locked arms. Pictures of mothers and nursemaids with children frequently include the children's toys. Social convention dictated not only dress and accessories, but also a woman's behavior during her walk; ideally she was to proceed without haste, at a comfortable and relaxed pace, pausing to rest when she pleased or stopping to admire something, greet an acquaintance, or chat. Unmarried women were for a long time accompanied by chaperones (frequently women friends or family members).

Very different rules applied to hikes and climbs in uncivilized, rugged terrain. These were seen not only as athletic activities but also as challenging and at times dangerous struggles against natural forces and a wilderness in which one might prevail only thanks to a "spirit of defiance." These therefore seemed unsuited to the weaker sex. Around 1900 it was still said that women should be prevented from mountain climbing; "they are an offense to society and look like Indian women." Nevertheless, women were increasingly drawn to solitary hikes in untamed nature as well as the mountain world, traditionally a male preserve, which they boldly fought for step by step, and at times shattering all social convention, clothing restrictions, and norms of female appearance and behavior. Gradually, with their pioneering achievements like climbing peaks in winter, they found entry into the hiking and mountain societies that multiplied after the mid 19th century. Bourgeois women mountain climbers had prominent models, among them noblewomen such as Empress Elisabeth of Austria.

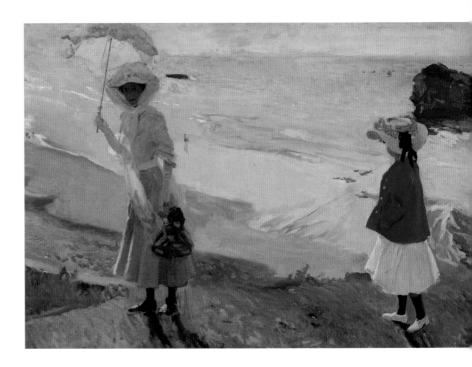

In the late 1880s one of the best-known women Alpinists was the Englishwoman Elizabeth Hawkins-Whitshed (1861–1934), referred to after her third marriage as Mrs. Aubrey Le Blond, an unusually emancipated and highly gifted woman. She not only discovered the mountain world for herself but also emerged as one of the first female Alpine photographers and writers of books on Alpine climbing. Her climbing career began in 1882, when she twice tackled Mont Blanc, the highest peak in the Alps. Her first attempt was aborted owing to inadequate footwear. In 1901 she dared something outrageous: a mountain tour without a male guide, anticipating the female Alpine clubs that came into being years later. With her pioneering achievements she shattered all social norms, and was well aware of it: in her memoirs published in 1928 she wrote: "I owe a supreme debt of gratitude to the mountains for knocking from me the shackles of conventionality."

In large part due to the emancipatory reform movements of the second half of the 19th century, women's fashions underwent dramatic changes. The corset was abandoned, as were tall, constricting shoes—even the pale complexion that up into the first quarter of the 20th century counted

as an essential attribute of feminine beauty. The first female mountain pioneers had worn white flannel dresses and tight-fitting boots or cloth shoes (which soon became water-logged). For a long time comfortable trousers continued to be taboo, as it was held that they were unflattering and tended to look masculine. Even so, daring women mountain climbers wore trousers under their skirts, which they removed as soon as they were certain no one was watching.

Women finally gained new freedoms at the turn of the 19th century. Walking and hiking, the most adventuresome set out as botanists and painters of plants and landscapes, to explore and conquer nature. From this time on they might undertake solitary treks in untamed nature. Whereas the first female mountain climbers after 1800 were still accompanied by male guides, now all-female rope teams became increasingly common.

Humankind has long been fascinated and challenged by wilderness. The conquest of mountains takes great effort and is fraught with danger, but though daunting, it can also be seductive. Confronting unspoiled nature, whether scaling a rock face or hiking through trackless mountain forests,

Joaquin Sorolla y Bastida, Spanish, 1863–1923
Lighthouse Walk at Biarritz, 1906
Oil on canvas, 26⅞ x 74¼ in.
Boston, Museum of Fine Arts

PAGES 30–31
Emilie Caroline Mundt, Danish, 1842–1922
Lady in White Reading, 1901
Oil on canvas, 20 × 32 in.
Hamm-Rhynern, Josef Mensing Galerie

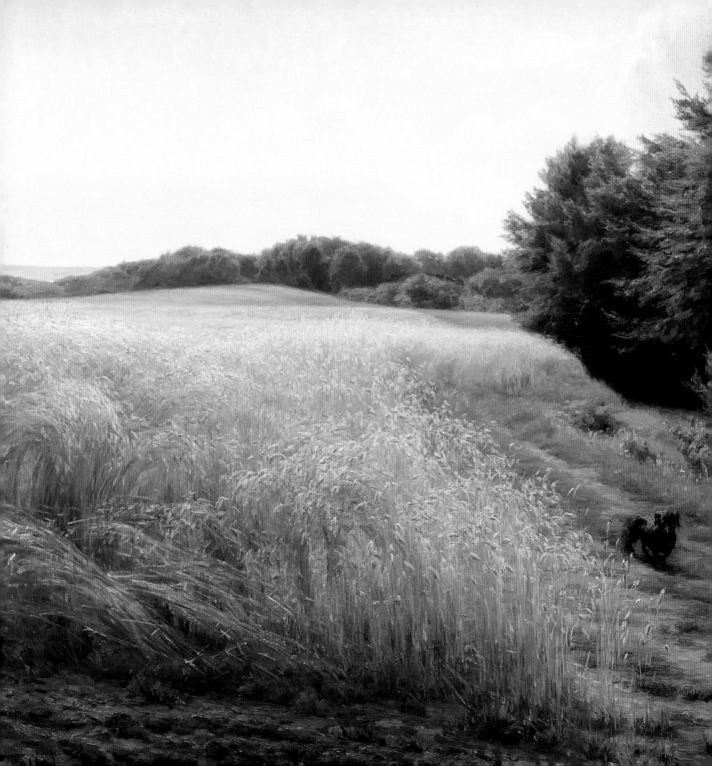

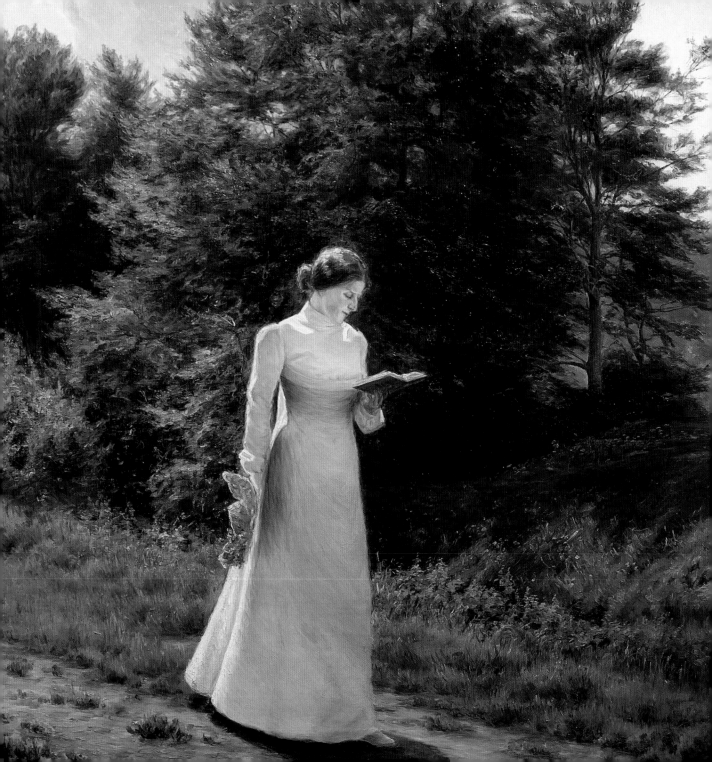

can produce a special feeling of happiness. Any number of modern women writers have confessed to a passion for walking, a virtual addiction to the interplay of muscle, sense, and consciousness, of free association, concentration, and memory. One of these was the English writer Virginia Woolf (1882–1941), a devoted walker. For her seemingly aimless London rambles she deliberately chose the muted light of dusk. Her long, brisk daily walks, her miles-long treks in Sussex and along the coast of Cornwall were, as she put it in her diaries, important for her literary creativity, for her discerning view of the world.

At the beginning of the 20th century, Woolf and women like her finally claimed what the spirit of the Enlightenment had called for, but what had so long been denied to them—walking as a means of self-discovery and experience of the world.

The best climber needs to take a seat at the top: there one has the most delicious view far out across the low shrubbery onto a plain ringed by mountains and filled with patches of forest, vineyards, villages, ancient ruins.

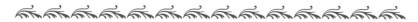

Johanna Kinkel, German, 1810–1858

Ernst Platz, German, 1867–1940
Descent Through the Höllental from the Zugspitze, 1900
Tempera, grisaille on cardboard, 19 × 13¾ in.
Munich, Alpines Museum des Deutschen Alpenvereins

ERNST PLATZ
MÜNCHEN

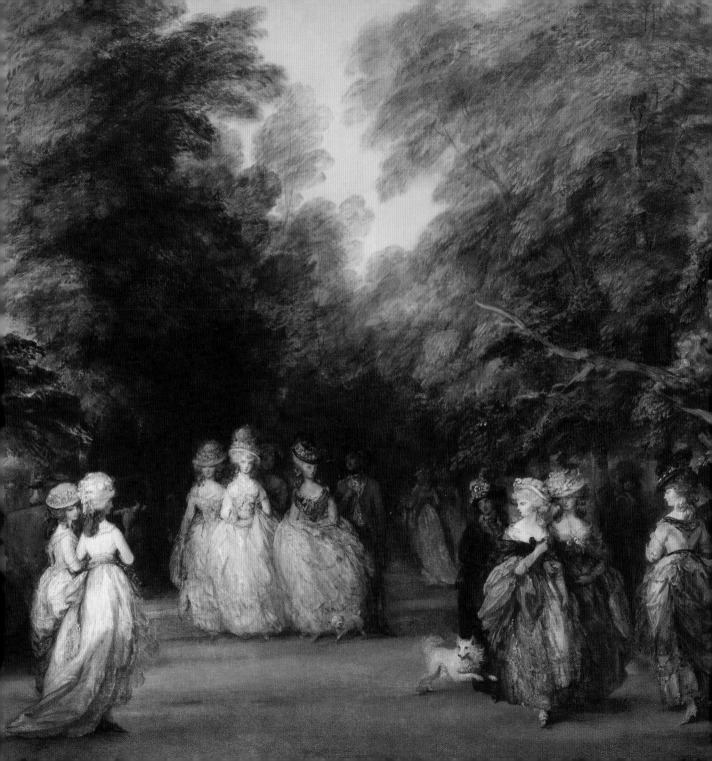

I. Aristocratic Promenades to Bourgeois Walks

Promenading is an expression of social standing

~~~~~~~~~~~~~~~~~~~~~~~~~~~~~~~~~~~~~~~~~~~

Honoré de Balzac, French, 1799–1850

Thomas Gainsborough, English, 1727–1788
*The Mall in St. James's Park* (detail), ca. 1783
Oil on canvas, 47½ × 57⅞ in.
New York, Frick Collection

*No woman of the higher classes would have gone even the shortest distance down the street without being followed by a servant, or in the absence of one, by her chaperone.*

Johanna Schopenhauer, German, 1766–1838

Promenades in baroque gardens were governed by their geometry and architecture, for gardens and parks with their central axes were meant to symbolize an absolutist claim to power and a hierarchical society. On established footpaths and along symmetrical allées men and women strolled in a rigid, artificial setting according to fixed rules of decorum. Aristocratic strolls were a regular feature of refined life at court, one dominated by gallantry, etiquette, courtesy, elegant manners, and witty conversation.

But in time walks on straight allées in an artificial nature with precisely clipped hedges and trees came to seem monotonous. And toward the end of the 18th century more and more aristocrats adopted Enlightenment thinking, which held that in such domesticated surroundings people cut themselves off from true nature and were thus prevented from experiencing genuine sentiments.

It was then, beginning in England, that a new type of landscaped park was introduced that in form and style was in sharp contrast to the richly ornamented baroque courtly garden. It was meant to reflect the natural landscape but with few barriers. In such modern parks nature symbolized the new socio-political notions of freedom-loving societies in constitutional monarchies. In a nature thus liberated and liberating and in a new style of walking people might find their way back to their roots.

But public strolls were still a matter of seeing and being seen, including the admiration of feminine beauty. Self-display was key to bourgeois promenades in the parks and gardens of the nobility, which beginning in the mid 18th century successively became accessible to all. There men and women of different social classes might meet "freely," so at first it was seen necessary to install guardians to uphold moral standards. Remote corners and winding walkways seemed only too tempting for all sorts of "dangers," from amorous encounters to lewd and unlawful behavior.

Pictures of the bourgeoisie strolling in public gardens and parks provide varied, at times caricatured visions of society in this period that are of interest as cultural history. For as the French writer Honoré de Balzac suggested around 1830 in his theory of the promenade, walking "at large" could not be so easily learned. A keen observer of his contemporaries, Balzac was convinced that a man's walk betrayed his character and that elegance was an inborn gift. He also considered creating rules for walking and thus a primer on the social life of his time.

In the 19th century urban green spaces became the favored places for city dwellers to walk, reflecting both a new bourgeois desire for contact with nature and an increasing focus on hygiene and a healthy lifestyle, which included exercise in fresh air. These urban parks were at the same time places for socializing and conversation. In this we also see the growing importance of bourgeois family life, in which women performed the roles of wife, housekeeper, and mother. Many of the public parks were transformed into playgrounds for children in the company of their nurses, nannies, or mothers. Walking in the park became a fixed event in the day's schedule for the entire family, at first only on Sundays and holidays, then later at the close of the working day and weekday evenings.

Only toward the end of the 19th century did it become possible for women to promenade alone in public green spaces without being thought to have loose morals. They still had to abide by the rules, namely to wear appropriate clothing, complete with hat, gloves, and parasol, and to bring along something indicating that they were not being idle: a book, handwork, or of course a dog.

After dusk, however, no virtuous woman would dare to enter a park without an escort. Prostitutes were the only women promenading there alone after the gas lamps had been lit. Women's true freedom to walk on their own was obviously impossible on these footpaths at this time of the evening.

Now it is impossible to imagine a city without public gardens. In today's public parks one can relax a while, even though certain behaviors and conventions must be observed. As protected enclaves closed off from much of car traffic and the business life of the city, parks offer space for socializing, recreation, and play. A walk in the park has long since ceased to be a matter of self-display, nor does it guarantee participation in the life of high society, as it did in the 18th and 19th centuries.

OPPOSITE
Pierre Charles Ingouf, French, 1746–1800
*Evening Promenade*
Engraving after a drawing by Sigmund Freudenberger, from *History of French Customs and Fashions of the 18th Century*, Paris 1775

PAGES 40–41
Johann Ziegler, German, 1749–1812
*A Part of the Augarten in Vienna*, 1783
Colored engraving
Vienna, Wien Museum

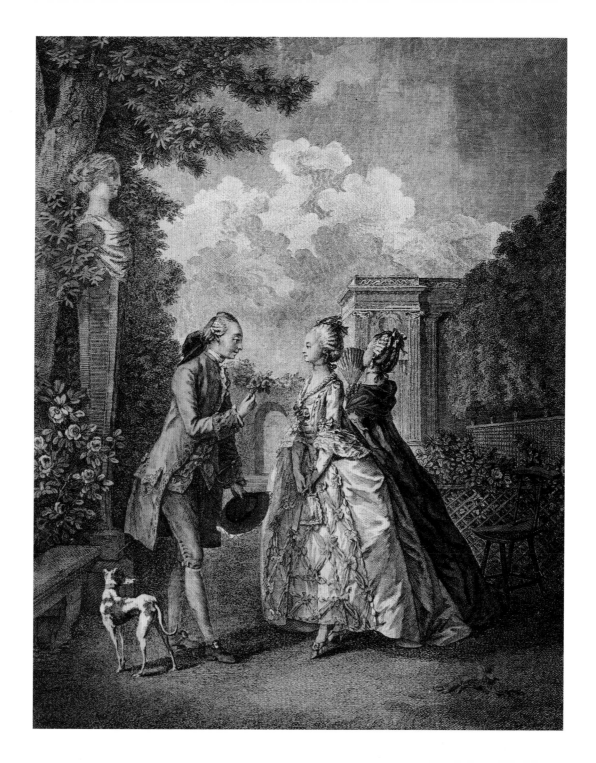

39

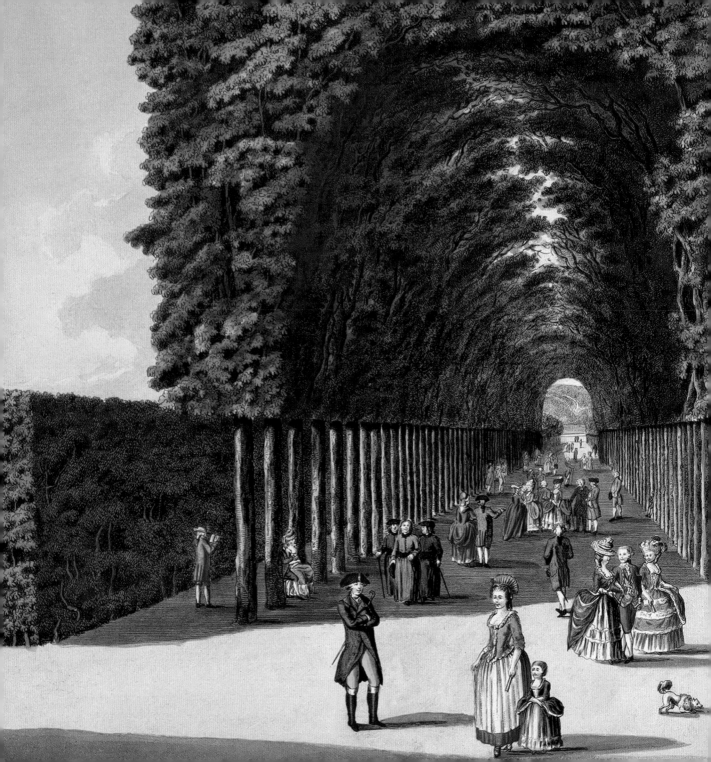

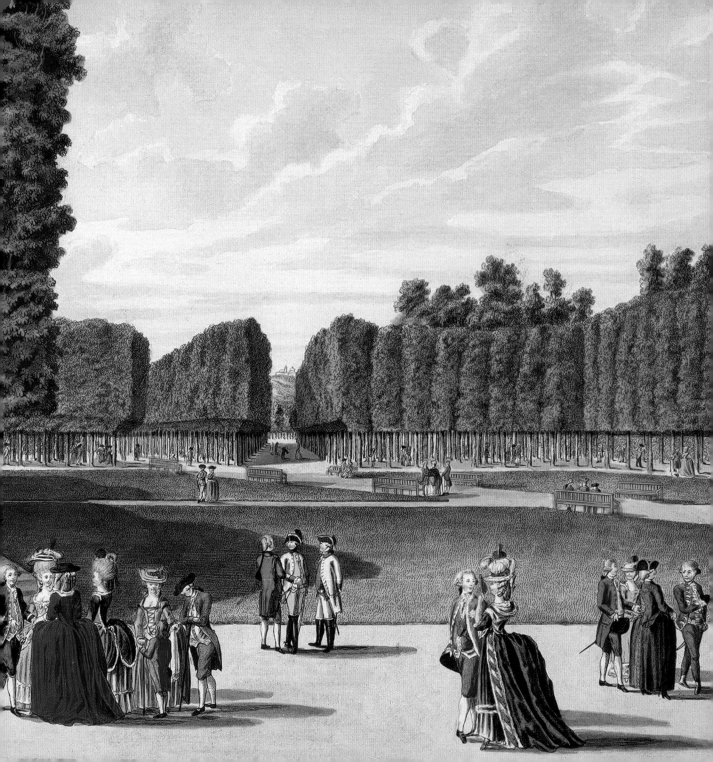

# A Few Fashion Follies

❧❧❧❧❧❧❧❧❧❧❧❧❧❧

The English writer Edith Sitwell (1887–1964) wrote amusingly about the fashion follies of her promenading countrymen circa 1800:

🕊 And here come these beaux, and the feather-witted, feather-crowned ladies who are their complements . . . The ladies now wear feathers exactly of their own length, so that a woman is twice as long upon her feet as in her bed. . . . A young lady, only ten feet high, was overset in one of the late gales of wind, in Portland Place, and the upper mast of her feathers blown upon Hampstead Hill. The feathers were those of the Argus pheasant, the Indian Macaw, the Argilla, the flat and porcupine ostrich, and the Seringapotum . . . and owing to the fashion of wearing muslin, . . . eighteen ladies caught fire, and another eighteen thousand caught cold.

Edith Sitwell, *The English Eccentrics*, 1933

Hendrik de Leth, Dutch, 1703–1766, and
Matthaeus Brouerius van Nidek, Dutch, 1677–1743
*Garden Elevation of the Country Estate Waterland
near Velsen with Promenaders* (detail), ca. 1721
Color lithograph, 5½ × 7¾ in.
Private collection

# Ornate
# Architectural Shapes

꙰꙰꙰꙰꙰꙰꙰꙰꙰꙰꙰꙰

The shrubs, hedges, and trees at Waterland, a country estate that came into the possession of Amsterdam's mayor Dirck Trip (1691–1748) in 1721, were clipped into ornate architectural shapes. Promenades took place in the symmetrical garden on geometrically laid-out paths, between rectilinear allées in an artificial nature. The approach to life of the wealthy burghers was thus reflected, for in the park they were not hoping to experience nature, but rather used it to demonstrate their all-encompassing power. Nature became only a backdrop for self-display.

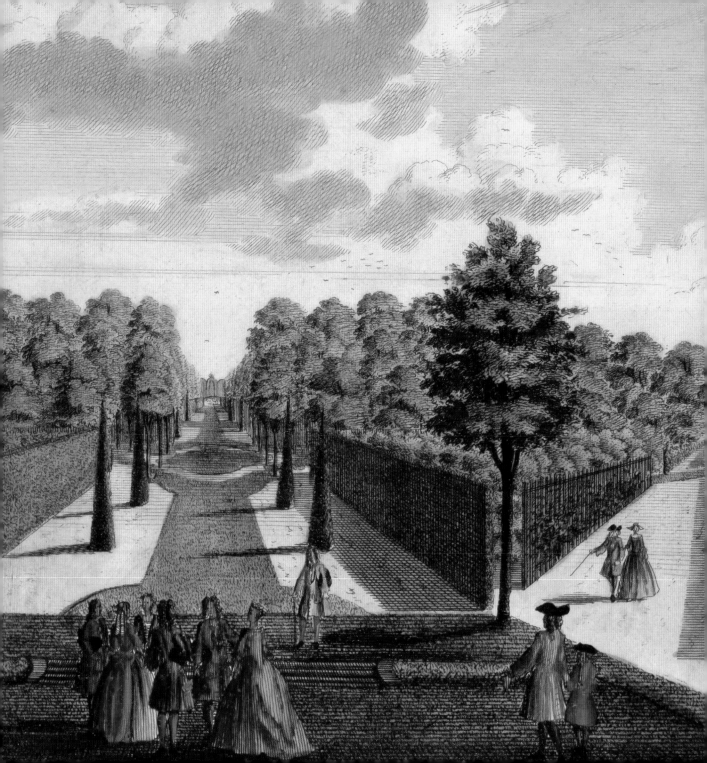

Pierre Thomas Le Clerc, French,
ca. 1740–after 1799
*Lady in a Violet Promenade Dress in
the Gardens of Paris's Palais Royal*, 1778
Colored engraving
Private collection

# Paying One's Respects

Walking in Parisian gardens and park-like promenades was a ceremony, one whose rules and conventions had to be respected. Everything was controlled, from the way walkers greeted each other to their gestures and poses. Promenades were largely rated according to the participation of high-ranking personages and beautiful women.

❧ Much depends on how and when one pays one's respects. Before persons of high rank and greater age one bows differently and with a different expression than one does to one's peers. The different sexes and our relationship to certain persons also require a different manner of paying respects. When a lady bows to a lady, a woman to a woman friend, her expression is warmer than when an unknown woman or a man approaches, where a certain reserve must prevail. . . . Many consider it quite rude if one does not bow as low to them as they feel they can require of us given

their rank. . . . Anyone who paid the same kind of compliment to persons of lower rank that they would to more distinguished ones would seem ridiculous, and only embarrass them. In general, good sense and paying attention to persons of refinement can best teach which ways of paying respect are most seemly and appropriate.

Johann Adolf Werner, *Female Physical Exercise for Health, Strength, and Grace* (*Weibliche Körperbildung für Gesundheit, Kraft und Anmuth*), 1834

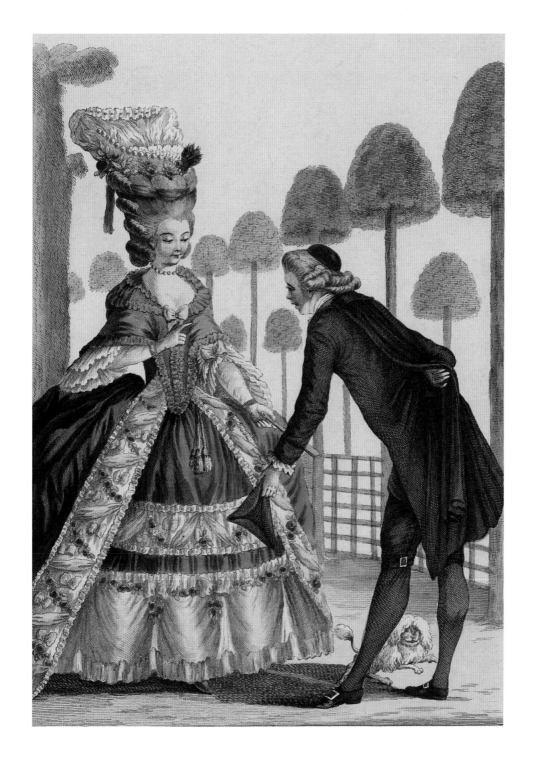

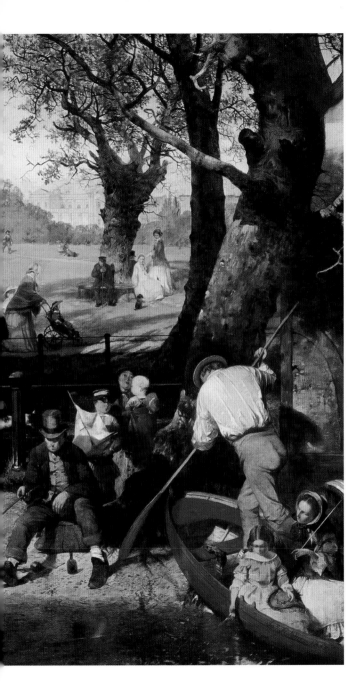

John Ritchie, active 1855–1897
*Summer Day in Hyde Park*, 1858
Oil on canvas, 50 × 30 in.
London, Museum of London

# London's Green Lung

H yde Park, London's "green lung," is one of the largest city parks in Europe. The park was opened to the public in 1851, greatly beloved because of its varied walkways and its wealth of trees. Then—as now—people could indulge a wealth of activities: horseback riding, picnicking, tennis, boat rides. Numerous 18th-century writings and guidebooks stress the importance of walking in the city, in its streets and parks, and how one was expected to behave.

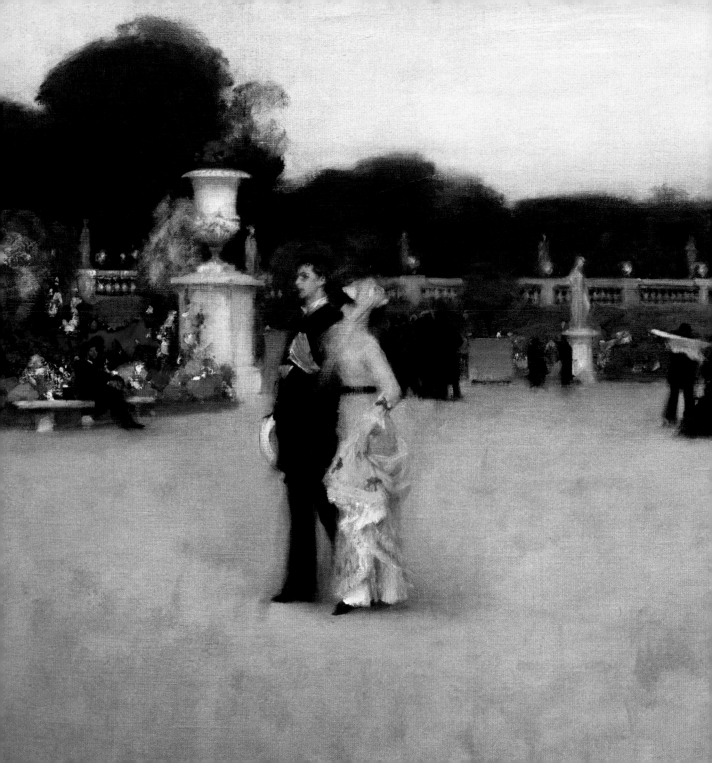

John Singer Sargent, 1856–1925
*In the Luxembourg Gardens*, 1879
Oil on canvas, 2⅞ × 36⅜ in.
Philadelphia Museum of Art

# Urban Recreation

The Jardin du Luxembourg, once a royal palace park, was one of the gardens transformed into recreational spaces for all Parisians under Napoleon III and his prefect Georges-Eugène Haussmann in the course of the redesign of Paris after 1850. Behind this opening up of public green spaces there was also a moral consideration. It would be better for workers to enjoy Sunday outings with their families or restorative evening walks instead of spending their free time in taverns. Needless to say decent women took evening walks only with an escort.

The American painter John Singer Sargent, who began his career in Paris and later in London, became the most sought-after and expensive painter for upper-class society. He is known for his technical facility and his precise and sensitive observations.

# Decorum's Demands

Already in the 19th century Johann Adolf Ludwig Werner (German, 1794–1866) pointed out the hygienic and pedagogical importance of gymnastics, and urged his contemporaries to exercise more. The study of kinesiatrics goes back to Werner. He first introduced exercise for girls in Germany in 1830, at a private school he had founded in Dresden. In 1839 he published a textbook filled with exercises, and a year later opened a gymnastic academy for boys and girls.

A person's consistent deportment, the manner in which he stands, walks, and sits, we call decorum. For each of these movements certain rules have been adopted. . . . No cultivated person can neglect physical decorum, inasmuch as it is the visible expression of our inner self, and virtually an imprint of it.

Decorum teaches certain rules relating to the body's attitude and posture, whether at rest or in movement, that no one should ignore if he wishes to be pleasing to others and not cause offense or be laughed at. How favorably the cultured, well-bred young woman differs from the uncultivated, rude example of her sex in all her physical movements! . . . The body must be erect, without stiffness, constraint, or stretching, as one sees it in soldiers standing in rank and file. Nature created us to be upright!

One should avoid excessive movement of the head, as one observes in pompous persons or coquettes; its movement should reflect an inner calm. It should also not hang forward or to the side; if it bends, it should find a middle road, not too high and not too low, not swiftly but with a certain reticence. One should never allow oneself to nod or shake one's head instead of making a reply. . . . Never grasp someone you are speaking to by his clothing; this represents an intimacy that could be offensive to one's superiors or to strangers.

There are also becoming and unbecoming ways of walking that to some extent betray the walker's character. A strong, forthright stride indicates courage, determination, self-confidence, also possibly pride. The man who walks this way can be forgiven, but a young woman should be more restrained, so as not to be accused of being domineering, commanding, disdainful, and proud. Many people are displeasing simply in the way they walk: the lethargic one walks slowly, the restless one quickly. A hesitant pace, if not excused by age or frailty, is indicative of weakness and a phlegmatic nature. Let cheerfulness and love of life prevail in the movements of youth, and the thoughtfulness of older people be exhibited

in their walk! On formal occasions a skipping walk would betray carelessness and frivolousness. Anyone who in his walking stands stiffly, and if I may say so thrusts his nose in the air as though wishing to ignore others, betrays the conceit of a vain and self-important person.

It is least attractive if when walking a young woman places her feet too far inward or outward, if she takes too long strides, if she appears labored, as though under a heavy burden. A too fast pace, if urgent circumstances do not require it, is unbecoming; it indicates restlessness, flightiness, and an erratic nature, and is inexcusable. Every rash movement is in defiance of good breeding. A swift pace easily turns into a kind of running that forces anyone approaching to step aside so as to avoid a collision. It is thoughtless and rude to force others to step out of our way. While children may run, the old and infirm walk slowly, let the decorous young woman choose a middle course. Heavy steps, so that one hears each footfall, are only permitted in common, uncultured people, not the well-mannered young woman, who should move about smoothly and quietly.

Johann Adolf Werner, *Female Physical Exercise for Health, Strength, and Grace* (*Weibliche Körperbildung für Gesundheit, Kraft und Anmuth*), 1834

Vittorio Matteo Corcos, Italian, 1859–1933
*Young Woman Walking in the Bois de Boulogne*, 1883
Oil on canvas, 51 × 32 in.
Private collection

# New Perspectives

After the French Revolution, Paris's Bois de Boulogne became increasingly run-down. As part of the modernization of Paris undertaken by Baron Haussmann for Emperor Napoleon III, the park was subjected to an exemplary redesign, with a new network of footpaths—no longer geometrically aligned—supplemented by rocks, grottoes, ponds, and the large lake visible here in the background. In the 1870s, following "Haussmannization," it became the most popular promenading spot in Paris. It attracted the city's most elegant people, eager to show off the newest fashions, like the costume of this young woman portrayed by the Italian painter Vittorio Matteo Corcos, an outstanding interpreter of modern life. According to one contemporary critic, his paintings of mostly young women with dreamy gazes—an expressive emphasis on the eyes was one of the artist's trademarks—depict self-confident young ladies walking on their own without an escort.

Corcos lived in Paris from 1880 to 1886, and loved the Bois de Boulogne, where women promenaded in every season; in this instance he chose to contrast the stroller's youthful bloom with an autumnal landscape.

In fact the young woman exhibits a distinct independence. She is holding a portable wooden camera, which were popular among amateurs and artists alike. It perfectly symbolizes how new perspectives were opening up to women on their own.

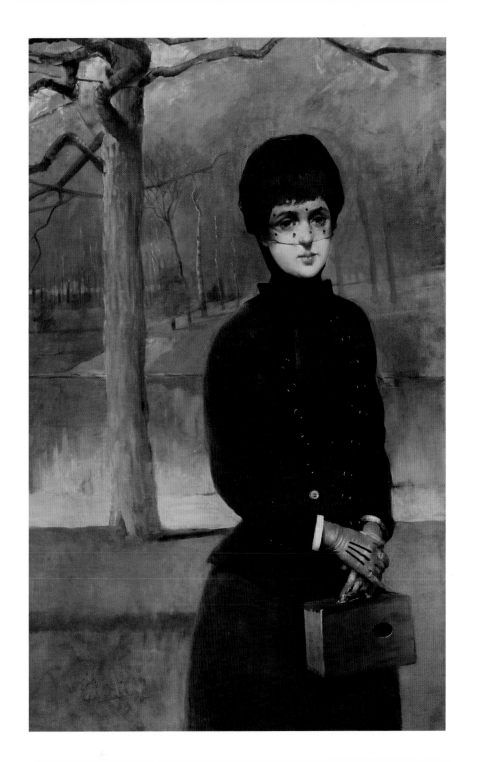

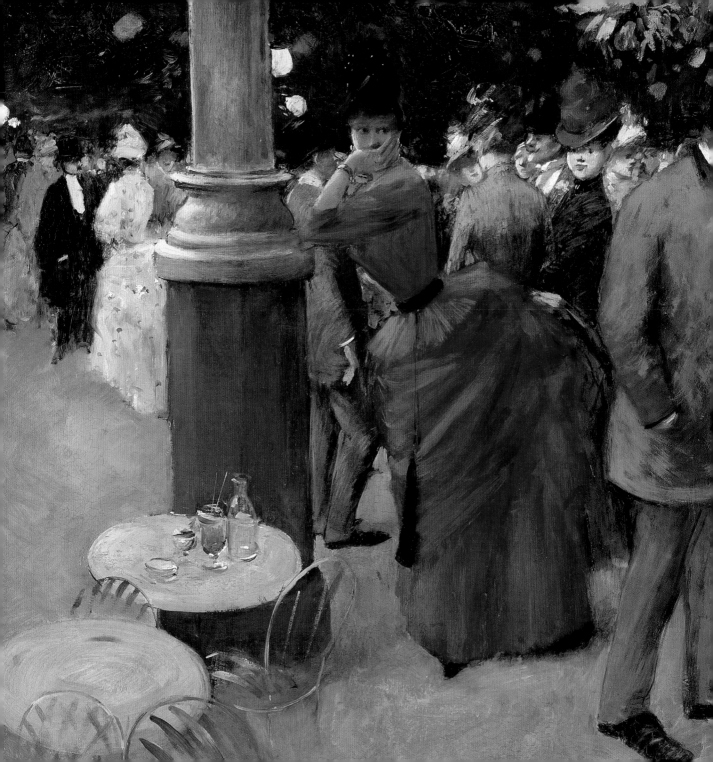

Jean-Louis Forain, French, 1852–1931
*In the Jardin de Paris* (detail), ca. 1884
Oil on canvas, 21½ × 18 in.
Private collection

# Telling Details

I n the second half of the 19th century the Jardin de Paris, extending from the Champs-Elysées to the Tuileries, was considered Paris's classiest park. Contemporary travel guides recommended visiting it for any number of reasons: "A park is not a salon. Its lines of intersecting allées encourage intimacies and certain liberties. Glances are exchanged, a glove or handkerchief falls, is picked up . . . ah, turns in the Tuileries Gardens all begin and end the same."

The reference is to the easy women and prostitutes who took to strolling in streets and parks at the onset of dusk, once the gas lanterns were lit. They could be identified by their clothing, their makeup, the way they walked, and their expressions. Such details as the fan hanging from the belt (never worn this way during the day), the bare forearms and hands (virtuous women customarily wore long gloves even in summer), the searching glance, and the provocative pose with the erotically emphasized padding at the rear of the dress (known as the Cul de Paris), above all the blatant colors of their dresses (here red), were the distinctive marks of women of easy virtue.

James Wallace, English, 1872–1911
*Autumn Walk in Kensington Park*, ca. 1900
Oil on canvas, 26 × 40 in.
Private collection

# Open Space in the Park

Kensington had always been (and is to this day) one of London's more elegant quarters. The British painter James Wallace chose to paint highly narrative city views, and with them created a portrait of the Victorian and Edwardian eras. At first parks and gardens were accessible to mothers and nannies accompanied by children only as a special dispensation. But over the course of the 19th century they became so popular as safe open spaces for everyday domestic visits that they increasingly lost their importance as places in which to make an impression. Social distinctions were now gauged by the play and clothing of the children, and the women hardly resembled their predecessors in the 18th century. They now came to the gardens primarily for the sake of the children.

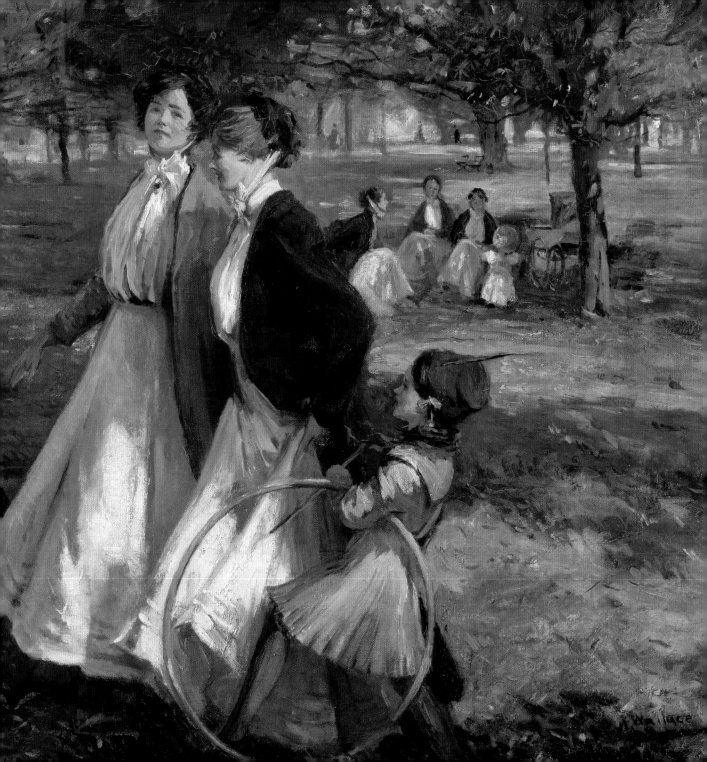

*I often go walking, either because the weather is glorious*
*or because I am anticipating the coming autumn storms.*
*So like a miser I use what God gives me.*

Marie Marquise de Sévigné, French, 1626–1696

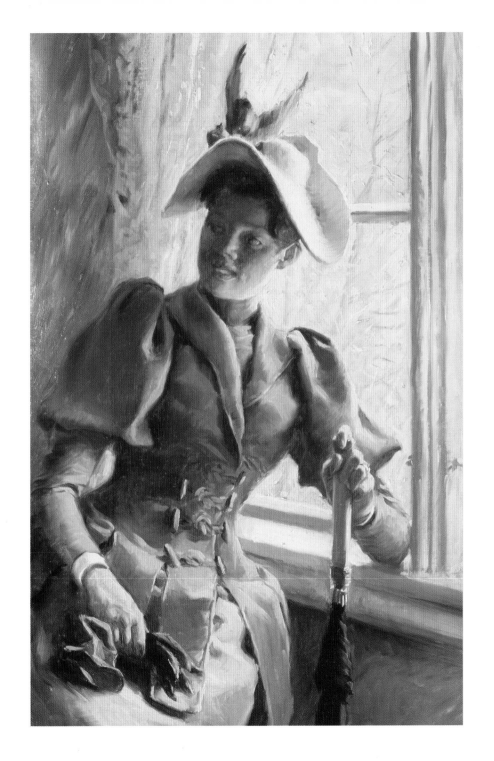

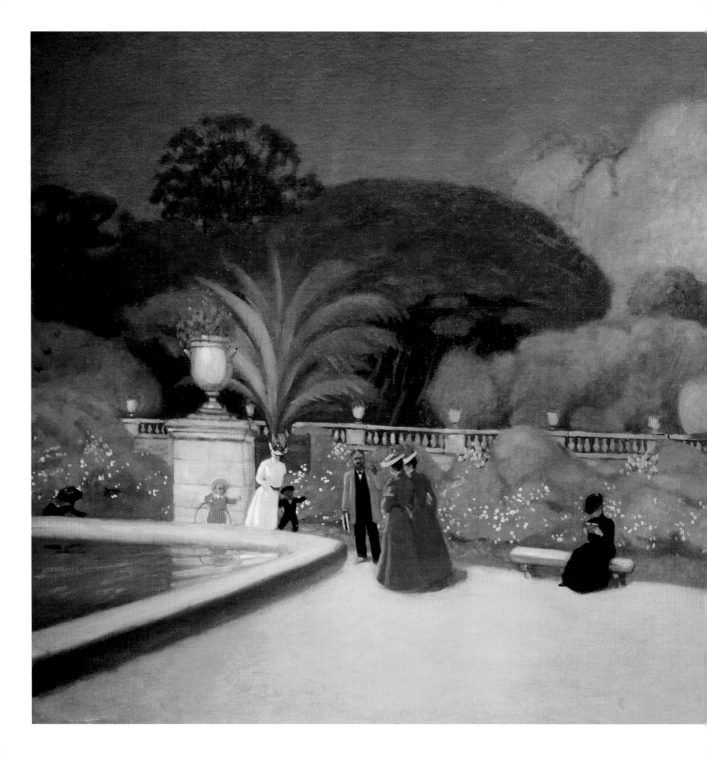

Félix Vallotton, Swiss/French, 1865–1925
*The Jardin du Luxembourg (Walk)*, 1905
Oil on canvas, 28 ¾ × 39 ½ in.
Private collection

# Inscrutable Atmosphere

A t the turn of the 20th century the city's recreational spaces became accessible to ever larger segments of society. Now even workers might promenade in the park with their families. However the French-Swiss painter Félix Vallotton chose to focus on the bourgeoisie, whose sham etiquette and pretension he at times attacked with biting irony. Here, owing to the mysterious light and the seemingly animated flora, something sinister appears to be brewing beyond the idyllic family outing.

In his semi-autobiographical novel *The Murderous Life* (*La Vie meurtrière*), written in 1907/08 and published only after his death—he describes his daily morning and afternoon promenades in the Jardin du Luxembourg. The carefully groomed vegetation and the park's architectural layout become the backdrop for the soigné and at times abysmal ennui of the big-city public.

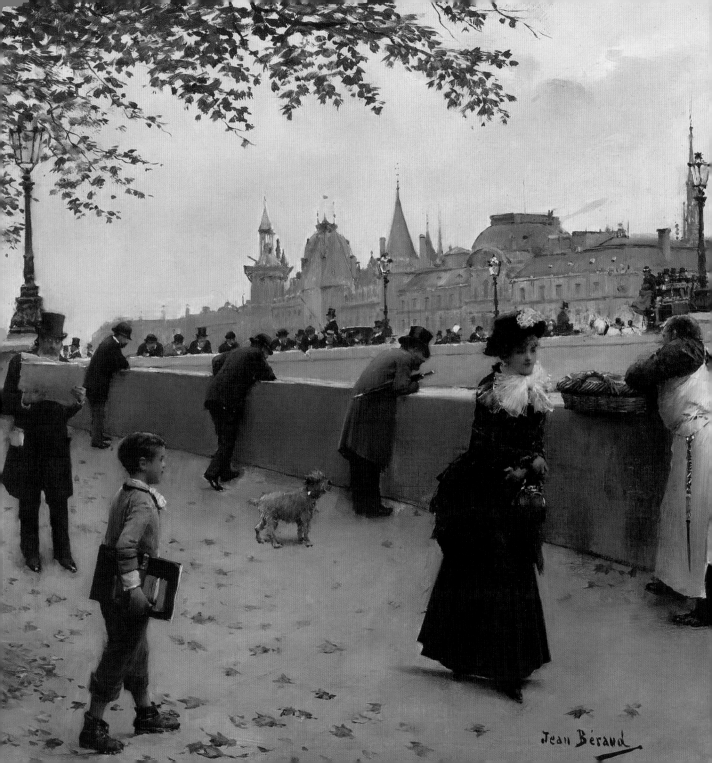

# 2. Strolling and Idling: On the Go in the City

*Unnoticed by painters until only recently, the modern street with its passersby . . . has now found chroniclers who capture our behavior and our stone landscape in pictures that are true to life, and that precisely for that reason will be collected by later generations.*

Ernest Chesneau, French, 1833–1890

Jean Béraud, French, 1849–1936
*Walk: The Pont Neuf in Paris*, 1880/81
Oil on canvas, 15½ × 19 in.
Private collection

*Villette is one blaze, one broad illumination; the whole world seems abroad; moonlight and heaven are banished: the town, by her own flambeaux, beholds her own splendour—gay dresses, grand equipages, fine horses and gallant riders throng the bright streets.*

Charlotte Brontë, English, 1816–1855

At the end of the 18th century, walking and hiking in nature were part of a new way of life for the rising bourgeois society. And with the much greater importance of the sciences in the 19th century, studies of dynamism and movement even considered the mechanics of walking. This newfound interest is reflected in the publication of a number of mechanical and sociological treatises on human locomotion, one of them the 1859 "Physiology of Walking" by the American writer Oliver Wendell Holmes. In it he referred to investigations into the mechanism of walking by the German brothers Eduard and Wilhelm Weber, who attempted to explain it in terms of physics.

Women participated in the new culture of walking to only a limited extent. Even though the growing metropolises provided new opportunities for walking, from the periphery into the center, on boulevards, squares, bridges, and the streets of the separate quarters, distinctions between the sexes were still visible.

How much the city walking of women differed from that of men can be seen in paintings of 19th-century European cities, especially Paris. Paris was indisputably the capital of the 19th century, the first city redesigned according to modern concepts, trend-setting in urban planning and in art. It had already become a popular subject in art by the end of the 18th century, but by no means to the degree it would be after Haussmann's renovation between 1853 and 1870.

With spacious new streets and sidewalks, avenues, and squares, it offered a previously unknown mobility and an entirely new blueprint of the city. Its bustling traffic and streams of strollers and idlers provided an exciting new sense of urban life. The pedestrian, male or female, became the symbol of 19th-century social realities.

Accordingly, painters captured the city best from the level of the pedestrian or while walking. This had become possible now that the streets were

more accessible, for with "Haussmannization" it became the norm for streets to be lined with sidewalks. The cleanliness and safety they provided fostered the appearance of the flâneur or the strolling female peering into shop windows. Strollers and their encounters, frequently presented anecdotally, became favorite subjects of art and literature.

In its fundamental modernity the new urban space was a male realm. And it would be male artists who produced a timely interpretation of city life. Contemporary women artists were excluded from it, and consequently they participated in the avant-garde to only a limited extent. Modern art was now to a considerable degree the product of the big city, the record of a new way of looking appropriate to the metropolis. It is reflected in art and literature in the figure of the flâneur, who simply enjoys the street scene on his aimless strolls.

It is hardly surprising that there was no visible female counterpart to him, for the world of the bourgeois woman in the 19th century was largely restricted to the private and domestic sphere. It was inappropriate for her, even morally suspect, to idly stroll the city's streets alone—unless she was window-shopping. The pedestrian consumer—logically enough—was pictured primarily in commercial art, less often in painting.

Into the start of the 20th century, the highly public street continued to remain somewhat off-limits to women, inasmuch as there they might be—willingly or unwillingly—suspected of prostitution. For a long time the female pedestrian experience was therefore quite different from that of the male. This difference is reflected in the fine arts through the end of the First World War.

It was finally in the 1920s that women—the English writer Virginia Woolf (1882–1941) was a prime example—conquered the city streets in the manner of the flâneur, claiming equal freedom of movement. But at this same time the motif of the female pedestrian lost much of its attractiveness to artists, given that leisure-time activity had changed fundamentallly, and the city stroll lost much of its importance. Though it occasionally turns up in painting even to this day, the new image of a woman walking on her own strides in an emancipated, self-confident way.

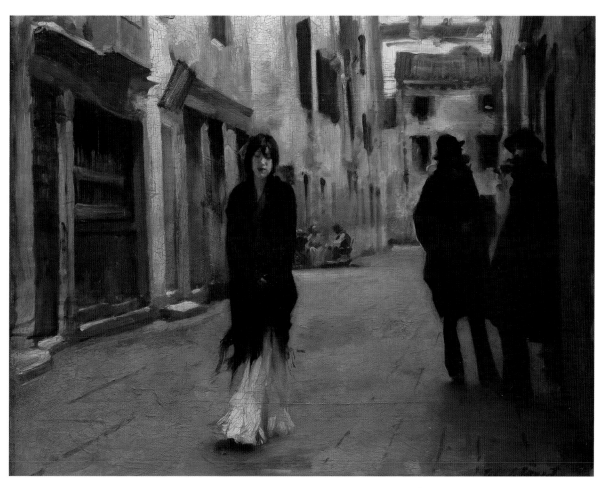

John Singer Sargent, American, 1856–1925
*Street in Venice*, ca. 1882
Oil on wood, 17¾ × 21¼ in.
Washington, D.C., National Gallery of Art

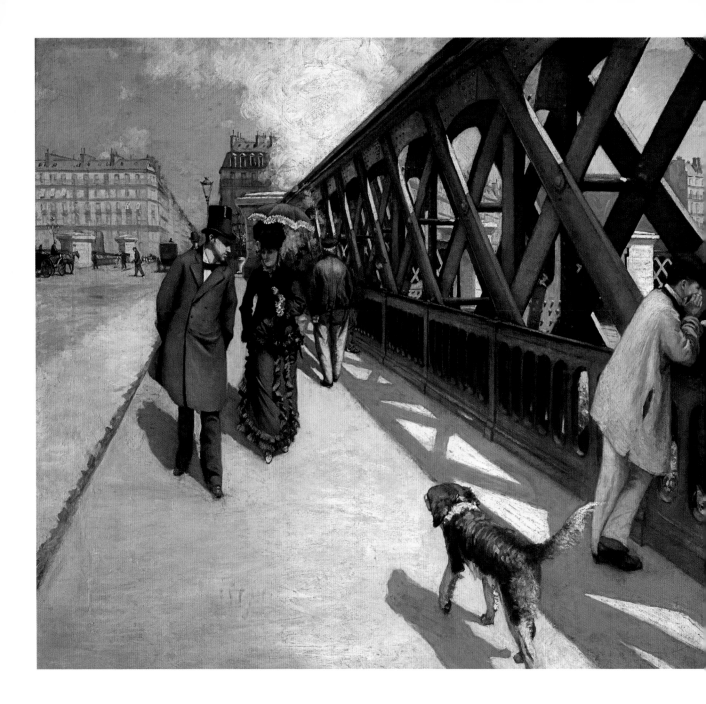

Gustave Caillebotte, French, 1848–1894
*Pont de l'Europe*, 1876
Oil on canvas, 49¼ × 71 in.
Geneva, Petit Palais

# Still One Step Behind

In this masterpiece by Gustave Caillebotte from 1876 the French painter directs the viewer's gaze to Paris's Pont de l'Europe quarter, and captures from the level of the pedestrian the structure and animation of the modern urban space: wide, straight streets with people in motion. It is not readily apparent whether the elegantly dressed gentleman and the woman with a parasol are a couple. The young man—contemporaries took him to be the painter's self-portrait—turns back toward the young woman, possibly Caillebotte's life partner at the time, but equally possibly a prostitute walking alone.

# The Marvelous Art of Balanced Locomotion

Oliver Wendell Holmes (1809–1894), the American writer, poet, and professor of anatomy and physiology, was one of the first doctors to establish a possible connection to hygienic conditions in the fight against widespread childbed fever. He published his first, gently ironic poems already in 1830, but he became known above all for *Autocrat of the Breakfast Table*, a collection of essays, anecdotes, and occasional poems. One of Boston's leading intellectuals, he was one of the upper-class "Boston Brahmins" who figured so prominently in New England culture.

The two accomplishments common to all mankind are walking and talking. Simple as they seem, they are yet acquired with vast labor, and very rarely understood in any clear way by those who practise them with perfect ease and unconscious skill. . . .

We wish to give our readers as clear an idea as possible of that wonderful art of balanced vertical progression which they have practised . . . for so many years, without knowing what a marvelous accomplishment they had mastered. . . .

In ordinary walking a man's lower extremity swings essentially by its own weight, requiring little muscular effort to help it. So heavy a body easily overcomes all impediments from clothing, even in the sex least favored in its costume. But if a man's legs are pendulums, then a short man's legs will swing quicker than a tall man's, and he will take more steps to a minute, other things being equal. Thus there is a natural rhythm to a man's walk, depending on the length of his legs, which beat more or less rapidly as they are longer or shorter, like metronomes differently adjusted or the pendulums of different time-keepers. . . .

We have selected a number of instantaneous stereoscopic views of the streets and public places of Paris and of New York, each of them showing numerous walking figures, among which some may be found in every stage of the complex act we are studying. . . .

The first subject is caught with his legs stretched in a stride, the remarkable length of which arrests our attention. The sole of the right foot is almost vertical. By the action of the muscles of the calf it has rolled off from the ground like a portion of the tire of a wheel, the heel rising first, and thus the body, already advancing with all its acquired velocity, and inclined forward, has been pushed along, and, as it were, tipped over, so as to fall upon the other foot, now ready to receive its weight.

In the second figure, the right leg is bend-

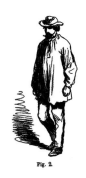
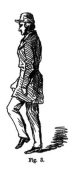
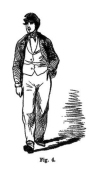

Fig. 1.      Fig. 2.      Fig. 3.      Fig. 4.

ing at the knee, so as to lift the foot from the ground, in order that it may swing forward.

The next stage of movement is shown in the left leg of Figure 3. This leg is seen suspended in air, a little beyond the middle of the arc through which it swings, and before it has straightened itself, which it will presently do, as shown in the next figure.

The foot has now swung forward, and tending to swing back again, the limb being straightened, and the body tipped forward, the heel strikes the ground. The angle which the sole of the foot forms with the ground increases with the length of the stride; and as this last surprised us, so the extent of this angle astonishes us in many of the figures, in this among the rest.

The heel strikes the ground with great force, as the wear of our boots and shoes in that part shows us. But the projecting heel of the human foot is the arm of a lever, having the ankle-joint as its fulcrum, and as it strikes the ground, brings the sole of the foot down flat upon it, as shown in Fig. 1. At the same time the weight

of the limb and body is thrown upon the foot, by the joint effect of muscular action and ac-quired velocity, and the other foot is now ready to rise from the ground and repeat the process we have traced in its fellow.

No artist would have dared to draw a walk-ing figure in attitudes like some of these. The swinging limb is so much shortened that the toe never by any accident scrapes the ground, if this is tolerably even.

. . . We find how complex it is when we at-tempt to analyze it, and we see that we never understood it thoroughly until the time of the instantaneous photograph. . . .

Two curious facts are easily proved. First, a man is shorter when he is walking than when at rest. . . . The other fact is, that one side of a man always tends to outwalk the other side, so that no person can walk far in a straight line, if he is blindfolded.

Oliver Wendell Holmes,
"The Physiology of Walking," 1859

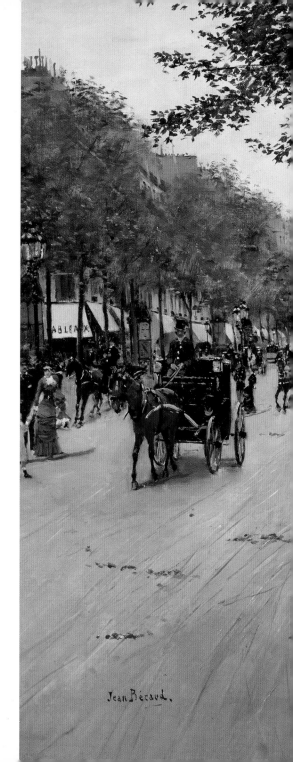

Jean Béraud, French, 1849–1936
*Paris's Boulevard des Capucines with Female Pedestrian*, ca. 1890
Oil on canvas, 20 × 28¾ in.
Private collection

# The Bustling City

Beginning in the mid 1870s the French painter Jean Béraud turned to everyday scenes with precise descriptions of Parisian life, creating multiple views of Paris's new boulevards created in Haussmann's modernization. One of the new swaths cut through the cityscape was the Boulevard des Capucines. These canyons opened up new perspectives with distant views and provided ready access and previously unknown mobility.

Crowding the boulevard are imperial buses, various horse-drawn cabs and modern streetcars—coupés and convertibles. A milling crowd of pedestrians fills the sidewalks. Daredevil men and women attempt to cross the street, putting themselves at risk of being struck by the approaching coaches; for a long time there were no traffic controls. Béraud's view of the beloved boulevard perfectly captures the vitality of the modern street.

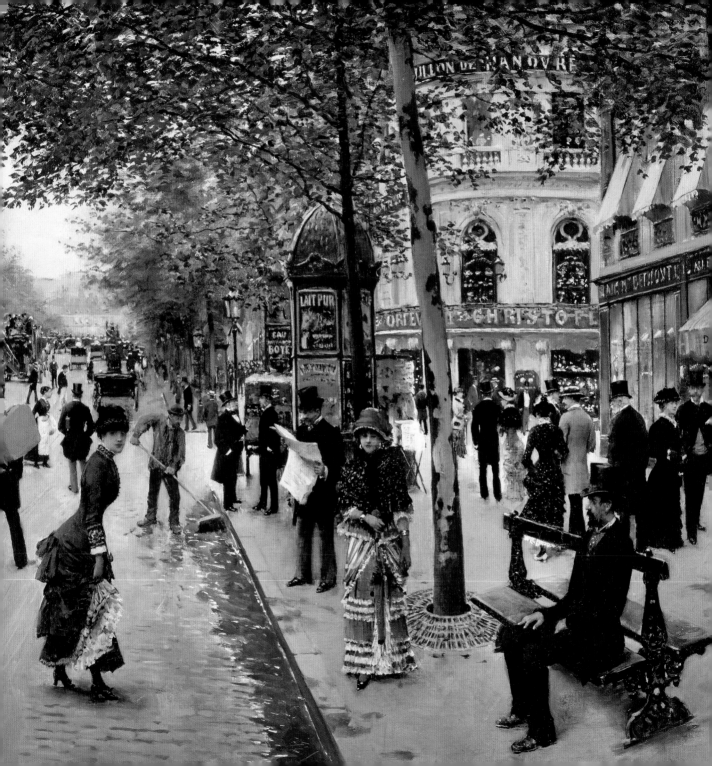

Aristide Maillol, French, 1861–1944
*Woman with a Parasol*, 1895
Oil on canvas, 75 × 58½ in.
Paris, Musée d'Orsay

# What Good Form Prescribes

As a lady, all colors are permitted to you, but choose them in such a way that they harmonize with your personality, especially your hair and complexion. If a brunette, bold colors like bright red, yellow-gold, and emerald-green will suit you best, if a blonde you should prefer such delicate colors sea-green, sky-blue, or pink. If a very young woman of 16 or 17, do not wear either violet or yellow-gold, and at 40 avoid pink and sky-blue. White and black you may wear at any age. . . . In your dress avoid anything conspicuous; to men it will seem precious and show-offy, to women unfeminine and provocative.

How should I walk? If you are a young lady, carry your head freely and charmingly high, and do not allow your gaze to sweep to either side, but rather direct it modestly to the fore. Let your walking be a graceful, gentle floating. – Do not run like a servant girl racing to attend to something, but also do not walk so slowly that you appear to be waiting for someone. Never walk bent over so that you run the danger of tripping over your own feet. Point your toes outward, step forward with the front part of your foot, not with the heel or with the sole flat on the ground. Bears walk on the soles of their feet, not human beings.

Constanze von Franken, *Catechism of Good Form and Refined Manners* (*Katechismus des guten Tones und der feinen Sitte*), 1890

*Young women should always be properly guarded and attended, according to their situation in life.*

Jane Austen, English, 1775–1817

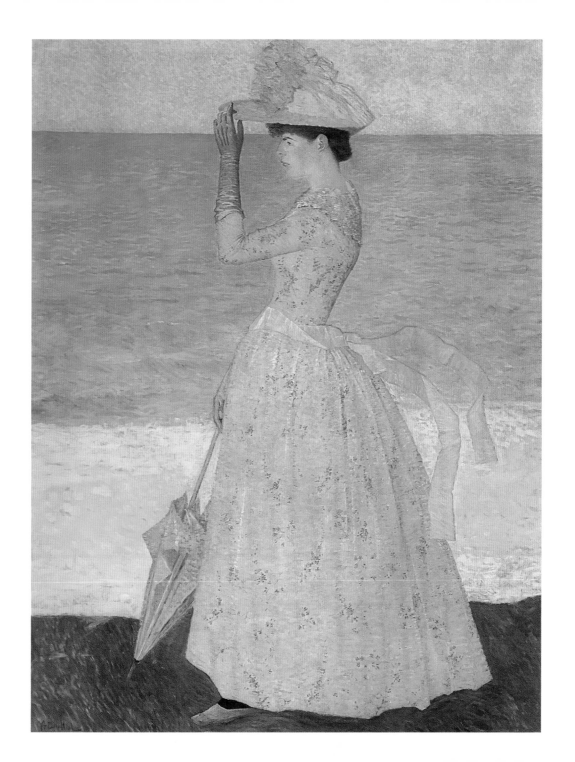

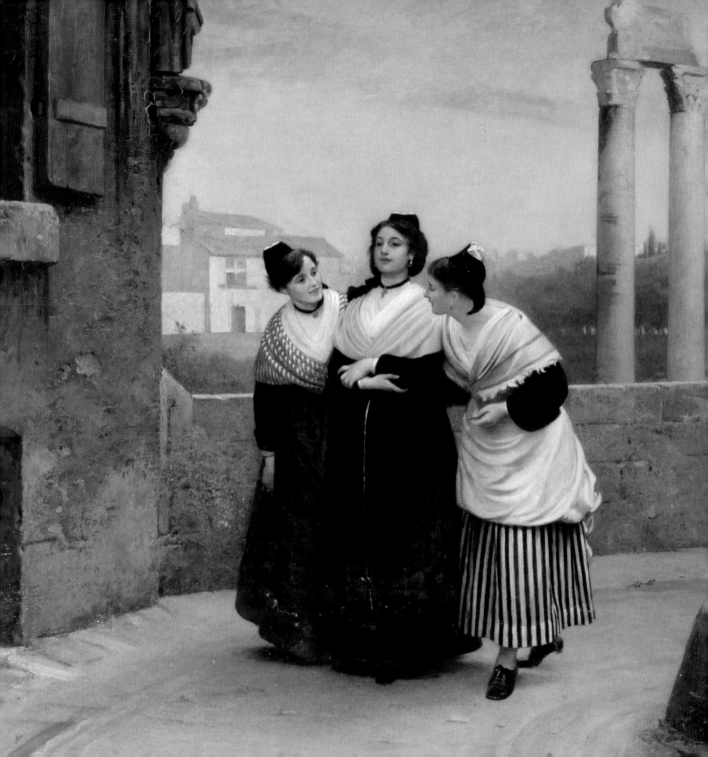

Philip Hermogenes Calderon,
English, 1833–1898
*Coquettish Strollers in Arles*, 1875
Oil on canvas, 35 × 46¾ in.
Private collection

# Covetous Glances

The bait tossed out by three young women taking a walk in Arles has been taken: they are being followed at an appropriate distance by an admirer quite obviously appraising them. This scene by the English painter Calderon illustrates how strolling coquettes, no matter how demurely dressed, might count on covetous male glances. For men one of the chief attractions of the promenade was making eye contact with a woman strolling alone or with female companions, onto whom, even if she did not provoke them with suggestive poses, gestures, and dress, he might project his fantasies.

The 19th-century pedestrian placed great importance on his or her outward appearance, for it was generally seen as an expression of personality. Over the course of the century clothing became more and more homogeneous and uniform, increasingly blurring social distinctions. Anything unusual or brightly colored was met with mistrust, and details and accessories took on increasing importance. To the initiated they served to provide information about one's social standing. The stroll thus proved to be like a fashion runway, and at the same time an opportunity to test one's cultural identity.

*In the first winter, when I still knew only few people, I often walked long distances alone, especially along the lake, which stared darkly beneath churning mists, and those were especially happy hours of hope-filled reveries.*

Ricarda Huch, German, 1864–1947

# An Irreplaceable Pleasure

I n her recollections *Braunschweig in My Childhood* (*Braunschweig in meiner Kindheit*), and in those of her school and university days in Zürich, *Spring in Switzerland* (*Frühling in der Schweiz*), the German writer Ricarda Huch (1864–1947), one of the first women to earn a doctorate, emphasized the importance of and differences between walking in nature and in the city.

If one wished to enjoy nature, those who had neither a garden nor a carriage and horses was obliged to hike. When I was small there were no public conveyances at all, and the horse-drawn buggies that then came along were by no means satisfactory. I recall a highly popular satirical song with the refrain: "been cancelled, been cancelled!" It amazes me when I now picture city traffic at that time, such that my grandmother, as far back as I can remember, no longer went out, because it was too noisy for her in the city.... Since any journey had to be made on foot, outings were generally restricted to one's nearby surroundings.... The dusty road one simply accepted without complaint.

On the evening of January 1, 1887, my brother and I arrived in Zürich.... On the following morning we went in search of a room for me, and the very first one we saw appealed to me.... I tended to get up at seven o'clock at the latest.... Then I would work with brief pauses until midnight. I had given myself a year in which to prepare for the entrance exam, and had to work hard if I wanted to reach my goal.... At the time I was ambitious and a hard worker. Since my school days I had not done anything serious for some eight years, but now I felt compelled to accomplish major assignments.... Toward evening I would often stroll alone or with Frau Wanner along the Hohe Promenade, the last fragment of the old bastion, where we would watch the evening light tint the Schneeberge. Only rarely would we encounter another pedestrian, who, like us, strolling past the overgrown graves of an ancient cemetry, was enjoying the evening.... In the first winter, when I still knew only few people, I often walked long distances alone, especially along the lake, which stared darkly beneath churning mists, and those were especially happy hours of hope-filled reveries. A few years later one of my female friends was attacked on the way to the Trichterhauser Mühle, and only saved by the approach of a small boy. This brought home to me the danger of solitary walks, and I lost my nerve for them, with which I gave up an irreplaceable pleasure.

Ricarda Huch, (above) *Braunschweig in My Childhood* (*Braunschweig in meiner Kindheit*), 1949; (below) *Spring in Switzerland* (*Frühling in der Schweiz*), 1938

Giovanni Boldini, Italian, 1842–1931
*Crossing the Street*, 1873–75
Oil on canvas, 18 3/16 × 14⅞ in.
Williamstown, Mass., Sterling and
Francine Clark Art Institute

# In Haste

G iovanni Boldini's lively street scene cap-
tures the accelerated city life of Paris.
As people scurry in different directions
one—unaccompanied—elegantly dressed lady
crosses the busy street, attracting the attention of
a man in a coach. In her haste she has lifted her
skirt so as to be able to walk faster, and there is a
seductive flash of her white petticoat. The Italian-
French painter Boldini leaves us wondering.
Perhaps she has just emerged from the elegant
coach in which the gentleman looks back at her
with such interest. Was her bouquet a thank-you
present? And is she now rushing home? Boldini
settled in Paris in 1871, and between 1873 and
1875 created this city scene.

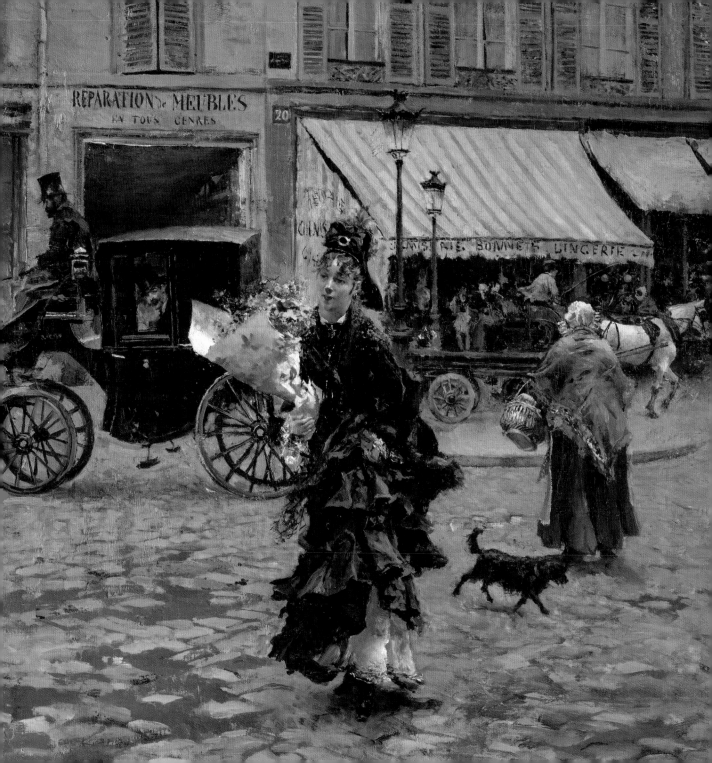

# City Ramble with Virginia Woolf

The English writer Virginia Woolf (1882–1941) regularly walked and hiked, whether in London, along the southwest coast of Cornwall, or in Sussex, where she had a summer place at Rodmell. From there she would undertake daily afternoon hikes of 6 miles (10 kilometers) each way to have tea with her sister Vanessa Bell at her artists' colony. These hours-long, brisk, and daily walks, as she called them in her diaries, not only helped to keep her in good physical condition, but were an important adjunct to her literary activity. Worth mentioning in the present context are her long rambles through London, which inspired her essay "Street Haunting: A London Adventure," first published in October 1927.

No one perhaps has ever felt passionately towards a lead pencil. But there are circumstances in which it can become supremely desirable to possess one. . . . so when the desire comes upon us to go street rambling the pencil does for a pretext, and getting up we say: "Really I must buy a pencil," as if under cover of this excuse we could indulge safely in the greatest pleasure of town life in winter—rambling the streets of London.

The hour should be the evening and the season winter, for in winter the champagne brightness of the air and the sociability of the streets are grateful. We are not then taunted as in the summer by the longing for shade and solitude and sweet airs from the hayfields. The evening hour, too, gives us the irresponsibility which darkness and lamplight bestow. We are no longer quite ourselves. As we step out of the house on a fine evening between four and six, we shed the self our friends know us by and become part of that vast republican army of anonymous trampers, whose society is so agreeable after the solitude of one's own room. . . .

But when the door shuts on us, all that vanishes. The shell-like covering which our souls have excreted to house themselves, to make for themselves a shape distinct from others, is broken, and there is left of all these wrinkles and roughnesses a central oyster of perceptiveness, an enormous eye. How beautiful a street is in winter! It is at once revealed and obscured. Here vaguely one can trace symmetrical straight avenues of doors and windows. . . . The eye is not a miner, not a diver, not a seeker after buried treasure. It floats us smoothly down a stream; resting, pausing, the brain sleeps perhaps as it looks. . . . Passing, glimpsing, everything seems accidentally but mi-

raculously sprinkled with beauty. . . . With no thought of buying, the eye is sportive and generous; it creates; it adorns; it enhances. Standing out in the street . . . Is the true self this which stands on the pavement in January, or that which bends over the balcony in June? Am I here, or am I there? Or is the true self neither this nor that, neither here nor there, but something so varied and wandering that it is only when we give the rein to its wishes and let it take its way unimpeded that we are indeed ourselves? Circumstances compel unity; for convenience sake a man must be a whole. . . . The pavement was dry and hard; the road was of hammered silver. Walking home through the desolation one could . . . give oneself the illusion that one is not tethered to a single mind, but can put on briefly for a few minutes the bodies and minds of others. . . . And what greater delight and wonder can there be than to leave the straight lines of personality and deviate into those footpaths that lead beneath brambles and thick tree trunks into the heart of the forest where live those wild beasts, our fellow men?

That is true: to escape is the greatest of pleasures; street haunting in winter the greatest of adventures.

Virginia Woolf, "Street Haunting: A London Adventure," 1927

Ignacio Zuloaga, Spanish, 1870–1945
*Aunt Luisa or the Chaperone*, 1903
Oil on canvas, 78 ¾ × 52 ¼ in.
Venice, Ca' Pesaro – Galleria Internazionale
d'Arte Moderna

# Well Chaperoned

Aunt Luisa accompanies two younger, probably unwed women—perhaps her two nieces—on a walk as a chaperone, thereby insuring their moral integrity in the face of possible attempts by male pedestrians to approach them.

In accordance with social etiquette the three are properly fitted out for the stroll in public: they wear hats, without which a lady never left the house until the beginning of the 20th century, buttoned walking shoes, and have brought their gloves. Aunt Luisa also carries a pouchlike bag (called a pompadour, originally intended to hold handwork) containing handkerchiefs, smelling salts, powder, and other everyday necessities, and has a small lap dog inder her arm as if to underscore the innocence of their joint promenade. Given the luxurious dog tax introduced in the 19th century (especially high for small dogs), the terrier can be interpreted both as a symbol of social status and, ambivalently, a suggestion of erotic desire and an inadmissable lust for adventure. For the point of the ladies' promenade is ultimately the possibility of making contact, presenting themselves to men's gazes and challenging their assessment. The complexion of the young woman in the center, dressed entirely in black, harmonizes with the ornament of yellow roses on her hat and the pink tone of her lips. She strikes a coquettish pose, only half concealing her inappropriately bare hands in the pockets of her jacket and gazing provocatively at the viewer. Certain promenades were seen explicitly as marriage markets, though we do not know where these three ladies were headed.

*On the Kurfürstendamm there are lots of women. They simply stroll. They have identical faces and many moleskin furs—so not entirely first class—but still chic—with prancing legs and lots of scent.*

Irmgard Keun, German, 1905–1982

# Such Was My Arrival in Berlin

Having grown up in Cologne and Berlin, after a brief career as an actress, Irmgard Keun (1905–1982) became famous almost overnight with her 1931 novel *Gilgi, One of Us* (*Gilgi, eine von uns*), which was followed in 1932 by *The Artificial Silk Girl* (*Das kunstseidene Mädchen*). The National Socialists banned her books, and she went into exile in 1936, traveling all across Europe with Joseph Roth. With a fake pass she survived the Nazi period as an illegal alien, but afterward was unable to repeat her earlier literary successes.

I'm in Berlin. For a few days now. After a night journey and with ninety marks left. This I have to live on until some sources of money present themselves. I have experienced terrible things. Berlin settled onto me like a quilt with fiery flowers.

The West is elegant, with brilliant light—like fabulous stones, extremely expensive with stamped settings. Here we have an excess of neon lights. Around me everything sparkled. And me with my squirrel. And debonair men like white slavers. Not that they traffic in virgins, which don't exist anymore—but they look as though they would if they could make money from it. Lots and lots of shiny black hair and deeply sunken, nighttime eyes. Exciting.

On the Kurfürstendamm there are lots of women. They simply stroll. They have identical faces and many moleskin furs—so not entirely first class—but still chic—with prancing legs and lots of scent. There's a subway, like an illuminated coffin on rails—underground and stuffy, and you get crushed. That's how I ride. It's very interesting and goes fast. . . .

And I arrived at the Friedrichstrasse station, where there were incredible crowds. . . . I was carried along in a stream on Friedrichstrasse, which was filled with life and color and has something checkered about it. There was some kind of commotion! So I immediately thought that this was an exception, for the nerves of such an enormous city as Berlin can't handle such frightful commotion every day. But I was dazzled, and I forged ahead—the atmosphere was exciting. And people raced and drew me along and we stopped in front of an elegant hotel called the Adlon—and everywhere there were people and police pushing them back. And then the politicians came onto the balcony like bland black dots. And everybody began screaming, and masses swept me past the police onto the sidewalk, hoping to have peace tossed down to them by the big politicians. And I screamed too, for the many voices entered my body and shot back out through my mouth. And I idiotically cried from the excitement. Such was my arrival in Berlin.

Irmgard Keun, *The Artificial Silk Girl* (*Das kunstseidene Mädchen*), 1932

# 3.  Liberating Steps into Nature

*. . . she went out sometimes in order to be alone for*
*a moment, and not to see before her eyes the eternal*
*garden and the dusty road.*

Gustave Flaubert, French, 1821–1880

Hans Andersen Brendekilde,
Danish, 1857–1942
*Walk in Spring* (detail), 1903
Oil on canvas, 29 ½ × 36 in.
Private collection

*Elizabeth continued her walk alone, crossing field after field at a quick pace, jumping over stiles and springing over puddles with impatient activity, and finding herself at last within view of the house, with weary ankles, dirty stockings, and a face glowing with the warmth of exercise.*

Jane Austen, English, 1775–1817

Walking and rambling in unspoiled nature as a deliberate, pleasantly liberating experience, as a school for observation, and as a sentimental perception of nature—this central facet of the bourgeois world view was subject to a considerable restriction well into the 19th century: women were excluded. Experience of nature was possible to the female sex only in company, and was thus denied to women on their own. If permitted at all, it necessarily had to be with a male escort or in familiar surroundings.

Even adventuresome female walkers avoided venturing into unfamiliar, untamed nature, for having internalized the proscription they found it made them uneasy, even in the company of men. For example, in the mid-18th century Meta Moller, a passionate walker even in winter storms, wrote to her later husband, the poet Friedrich Gottlieb Klopstock: "I once climbed a mountain. . . . I was anxious . . . but once I was on top it was truly beautiful."

Heading out into nature indeed held dangers and risks for which women were ill prepared. For one thing, women were not encouraged to develop sufficient physical strength. For another, given the prevailing fashion her clothing was an impediment, and made hiking risky. The humorous poet and draftsman Wilhelm Busch was inspired to relate one such venture in his satirical picture story "Adele's Walk" ("Adelens Spaziergang").

The degree to which "wild" nature could be experienced by women as a dangerous place can be read in a central episode in Dorothea Schlegel's novel *Florentin* (1801). In it a hike serves to bring the two sexes together outside of normal social boundaries. The title hero Florentin agrees to go hiking with Eduard and Juliane, who are shortly to be married. Juliane is only permitted to go if dressed as a man, so that her gender is not immediately apparent. Yet the equality is deceptive. For to the degree that walking enhances her experience of nature, her sexual identity becomes visible—

venturing out into nature was always interpreted as an experience of love in all its facets. With her flushed cheeks and loosened hair the woman awakens the desire of the men hiking with her, which makes her feel insecure, even to fear the unknown. The customary rules cease to be valid out in nature, and there is the danger that she will go astray and in every respect lose her orientation. Here the narrator reveals a new, feminine view of the world, a fear of exposure and being unprotected.

A frequent symbol of this in art and literature is a walk in the forest that a woman does better not to take, for otherwise, by crossing a (dangerous, derelict) bridge she symbolically leaves civilization behind and enters into "wilderness" (the home of wild beasts).

At first glance hikes on trackless rocky cliffs along the coast—alone or with a female companion—would seem no less dangerous. Yet over the course of the 19th century, medicine recognized the health benefits of exposure to sea air, and such rambles and beach walks were increasingly permitted, even encouraged. Paintings of girls and women hiking along the tops of cliffs above beaches combine in exciting ways the terror of heights, the grandiose ruggedness of cliffs, with the deeply rooted sense of the sea as a realm of the feminine.

Walking on the beach, the adjacent expanse of the sea, the wet sand beneath one's feet, gives rise to emotions, so that drunk with the feeling of treading on new shores, the sea with its endlessly swelling waves becomes the embodiment of desire. Thus the female stroller in the midst of the natural spectacle she is experiencing—virtually a symbol of challenge and probation—becomes an erotic image, the image of a feminism both menacing and salutory.

The solitary female beach walker: in trousers—the most masculine of all garments—and free of shoes, barefoot, even nude, treading new new shores, is a wonderful symbol of the emancipation of women in the 20th century. They now stand on their own—and now women create pictures of women.

Ilya Yefimovich Repin,
Russian, 1844–1930
*Summer Landscape*, 1879
Oil on canvas, 14 ¾ × 24 in.
Moscow, Pushkin Museum

Philibert-Louis Debucourt, French, 1755–1832
*The Young Woman or the Amorous Walk*, ca. 1805
Aquatint, etching, 13 × 17 in.
Paris, Musée du Louvre

# On the Pathways of Amor

By experiencing love in all its forms one develops an understanding of nature. For only then, according to the thinking of the Romantics, does one truly discover nature and oneself. Whether this will happen to these three is uncertain. But their stroll certainly promises an adventure—what a wonderful reason to get out in nature.

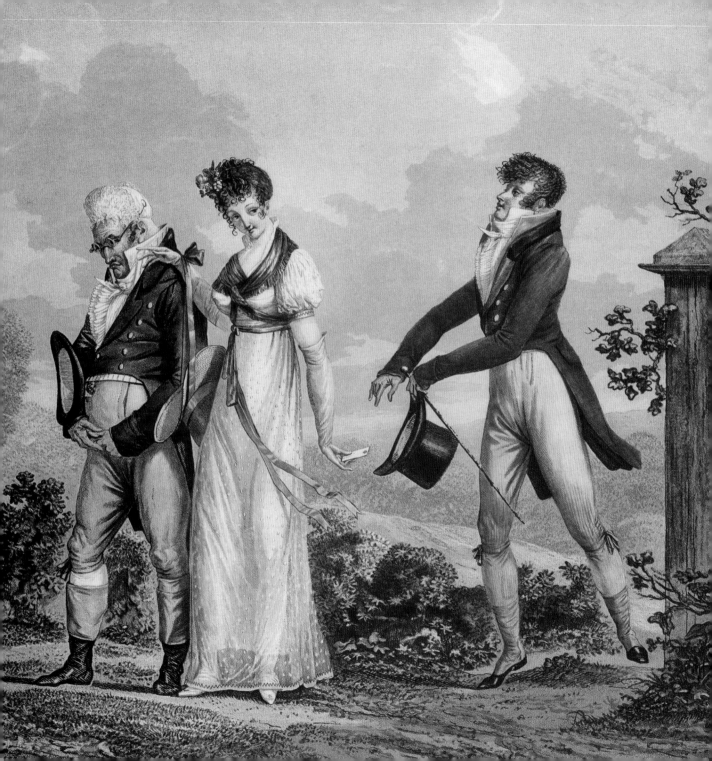

Ein Mädchen schön und voll Gemüt,
Geht hier spazieren, wie man sieht.

Sie pflückt auf frühlingsgrüner Au
Vergißmeinnicht, das Blümlein blau.

Ach Gott! da hupft ein grüner, nasser,
Erschrecklich großer Frosch ins Wasser.

Adele, die ihn hupfen sah,
Fällt um und ist der Ohnmacht nah.

Ameisenbisse tun gar weh;
Schnell springt Adele in die Höh'.

Ein Schäfer weidet in der Fern';
Den Ziegenbock hat man nicht gern.

Es stößt der Bock; Adele schreit;
Der Hirt ist in Verlegenheit.

Auf seine Hörner nimmt der Bock
Adelens Krinolinenrock.

Hund, Hirt und Herde stehen stumm
Um diesen Unglücksfall herum.

Der Schäfer trägt Adelen fort;
Ein Storch kommt auch an diesen Ort.

Schnapp! faßt der Storch die Krinoline
Und fliegt davon mit froher Miene.

Hier sitzt das Ding im Baume fest
Als wunderschönes Storchennest.

Wilhelm Busch, German, 1832–1908
*What Can Happen to a Young Woman When
She Sets Out on a Solitary Walk in Nature*
Woodcut after drawings by Wilhelm Busch,
from *Münchner Bilderbogen* Nr. 376, 1859

# Adele's Walk

To the Romantics unspoiled nature symbolized the self-determined life and intellectual independence. On solitary rambles in nature (as opposed to strolls in civilized public spaces) the solitary wanderer, walking at his own rhythm, can come to new levels of self-discovery. Since women were excluded from such activity, in art female figures appeared in nature either as luxurious seductresses, simple, uncorrupted children of the Alps, or helpless virgins exposed to danger. Wilhelm Busch (1832–1908), the satirical German draftsman, painter, and writer, chose to illustrate the latter. A master of subversive contemporary criticism, he here castigated the era's insane fondness for crinolines.

# "They passed through the forest toward the mountains, happy and untroubled"

꧁ ꧁ ꧁ ꧁ ꧁ ꧁ ꧁ ꧁ ꧁ ꧁ ꧁ ꧁ ꧁

The Romantic German writer Dorothea Schlegel (1763–1839), who herself suffered under the rigid gender roles of the time, explored them in her first novel, *Florentin* (1801), through the figure of Juliane, and in her description of a hike in untamed nature exposed the dangers facing women who overstepped barriers.

Kaspar Kögler, German, 1838–1923
*Goethe Walking with Johann Christian Kestner and Charlotte Buff*, ca. 1773
Wood engraving, 1880

꧁ Eduard and Florentin had undertaken shorter journeys into the mountains and the surrounding region several times. In changing disguises . . . either as peddlers or actors. They had had a number of amusing adventures that they by no means regretted. Returning from their wanderings they had much to tell, and spoke of the conquests they would have liked to make. Juliane concocted the notion of sometime going with them; and the next time the two young men were about to set out on such an adventurous journey she told Eduard that she wanted to come along. . . .

The count and his wife were greatly opposed to the idea, and at first refused to permit it under any circumstances. It was an affront to their station, Juliane's health would be endangered, not to mention the other dangers and her own anxiety. Florentin, who had set his mind on the plan, and Eduard, who felt he had

a right to demand their permission, continued to beg and to propose the venture until it was given them, only under the condition that they did not go on horseback but only on foot, and that they would not be away overnight. And now so many preparations were made, so many rules and warnings handed down, that Juliane, grown quite anxious, swore to herself that she would certainly not overstep in any way, and that this was the last time she would ask for such a concession. . . .

Since Juliane . . . frequently rode dressed as a man, she was not unused to it; she moved as easily as if she had never worn any other garments. . . . They passed through the forest toward the mountain, happy and untroubled (singing and dancing). . . . Juliane, flushed . . . leaned against Eduard, a gentle breeze rustling in the high tops of the young birches cooled her heated face and blew back the locks that become unpinned in her movement by their own weight and now fell below her waist.

Gazing at her beauty Eduard was completely dazzled . . . and forcefully clutched Juliane against his breast; oblivious to the presence of his friend, he could not restrain himself, and pressed his lips firmly against hers, his embraces grew bolder, he was beside himself.

Juliane was shocked, skillfully wrenched herself out of his embrace, and stood up, casting an angry glance at him. Eduard was shattered, to calm him she extended her hand, which he covered with kisses. . . . The high spirits and the growing wantonness of the two began to alarm her, she now found her undertaking to have been rash and exceedingly daring; in her fear the two men struck her as altogether alien, she was terrified at being so completely at their mercy; for a moment she could not even recall how it was she related to them. She trembled, grew pale.

Dorothea Schlegel, *Florentin*, 1801

Juliane's brief pretense of equality with the men is finally destroyed when a storm breaks over them; she is close to fainting with fear, and her feminine "weakness" is exposed. Her seeming emancipation is ultimately withdrawn, for in view of the hike into the unknown mountain world she recognizes her dependency and comes to the conclusion that she dare not transgress against bourgeois conventions.

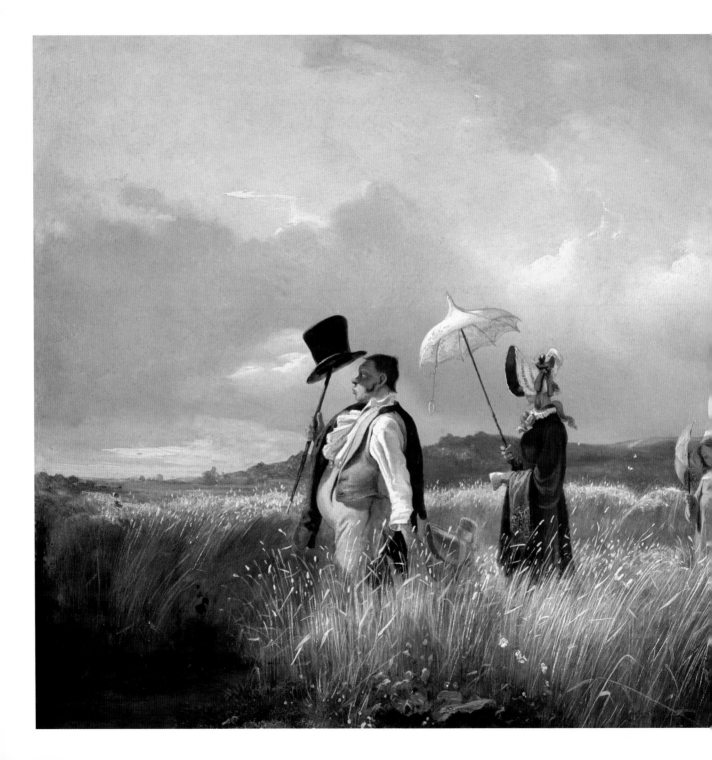

Carl Spitzweg, German, 1808–1885
*The Sunday Walk*, 1841
Oil on canvas, 11 × 13½ in.
Salzburg, Museum Carolino Augusteum

# Broader Perspectives Undesired

~~~~~~~~~~~~~~~~

Guided by the head of the household, a family heads out beyond the city gates for its Sunday outing in nature—surely no particular delight in the middle of a wheat field in oppressively hot, close air indicative of an approaching storm. It's unthinkable that they might cast an appreciative glance about them; the girl and the women wear hats cinched close to their faces like blinders, making views of the landscape virtually impossible. And as we know, they were not encouraged.

Erik Werenskiold, Norwegian, 1855–1938
In Familiar Surroundings, 1882
Oil on canvas, 18 × 22 in.
Lillehammer, Kunstmuseum

Well Protected in Nature

A walk in nature on recognizable, well-known paths, but—as is clear from the picture—without an expansive view of the horizon. Two white wooden chairs, empty as yet, suggest a gardenlike landscape in which the solitary walker on familiar territory might take a seat.

Miraculous is the power that a noble female exerts over the male spirit, and with that power she extends her influence far beyond the limits of her domesticity and into the furthest circles.

Friedrich Evertsbusch, German, 1813–1888

Woman as Guardian of Morals

The woman's realm was indoors, not outdoors; she was not to overstep its boundaries, either in thought or deed. Books of decorum like this one by Friedrich Evertsbusch were especially popular in the 19th century and favored as gifts to young women.

❧ For the joys of the house reveal themselves to you most delightfully. The house is the woman's proper home. This is the setting for your activities, and accordingly your greatest happiness. For happiness springs from activity, it wafts toward you from your governance. . . . Miserable is the young woman who seeks her greatest joys outside the house, but does not find them. . . . The man strives to produce and expand his possessions, the wife to preserve and protect what is at hand. Just as she manages to hold together the externals of the house, attentive to each smallest detail and making use of it, it is she who also preserves its spiritual assets and passes them on to future generations. The wife is called to be the guardian of morals. Breaching the barriers of morality is rightly considered to be unwomanly.

A woman's place is primarily in the familiar rooms of the house and somewhat further in the social circles that bind house to house. . . . Miraculous is the power that a noble female exerts over the male spirit, and with that power she carries her influence far beyond the boundaries of her domesticity and into the furthest circles. It does not itself venture into the marketplace of life; but it functions along with the man's deeds and plays its part in the thinking and actions that move the world.

Friedrich Evertsbusch, *Guide to Young Women's Decorum* (*Anstandsbuch für junge weibliche Leser*), 1867

Peder Severin Krøyer, Danish, 1851–1909
Summer Evening on the Beach at Skagen
(detail), 1893
Oil on canvas, 39½ × 59 in.
Skagens Museum

Autonomous Women

Around 1900, strolling on the beach (here in the golden hour of dusk), was considered beneficial to one's health and thus permitted to women, whether promenading alone or with a companion.

We do not know whether the two Danish painters Anna Ancher (1859–1935) and Marie Krøyer (1867–1940) were walking barefoot through the sand. It would have been part of their unconventional way of living, yet in their long white summer dresses they were in conformity with the period's prevailing notions of femininity. As it happens, however, these self-confident artists, like their painter husbands Peder Severin Krøyer and Michael Ancher, belonged to the so-called Skagen artists' colony. In the 1880s the members of this nonconformist living and working commune devoted themselves to plein-air painting in the French style, and in an original manner combined realistic and naturalistic approaches with the spontaneity of Impressionism. With its long white sandy beaches and coastal light, Skagen, Denmark's northernmost port city, served as an ideal setting for such paintings.

The degree to which Marie Krøyer broke with the conventions of her time is evident from a glance at her biography. She was not only a gifted artist who paved the way for the following generation of women painters, she also led a highly unusual life outside of bourgeois norms. Though married, for more than ten years she lived with both her lover, a Swedish composer five years younger than she, and her husband, in a triangular relationship that was blessed with children.

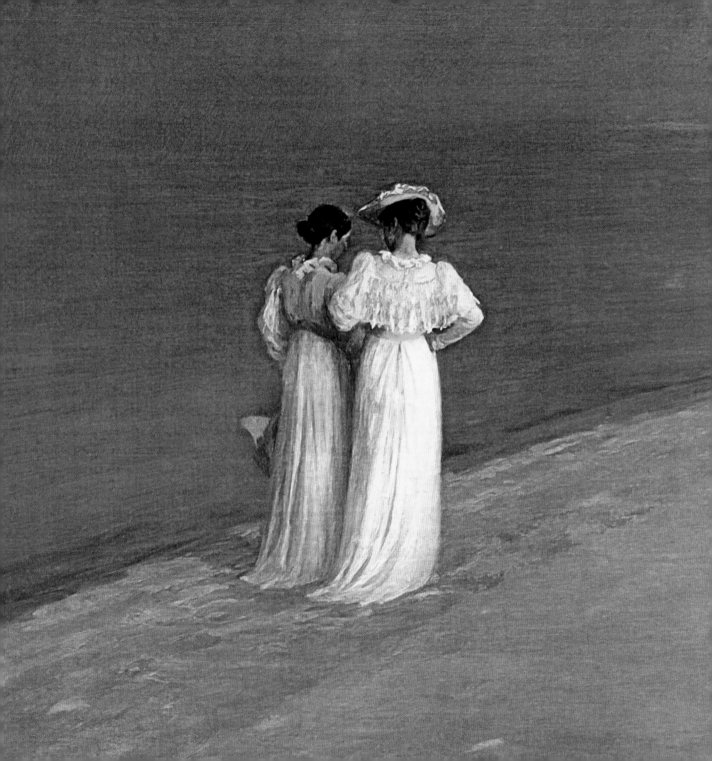

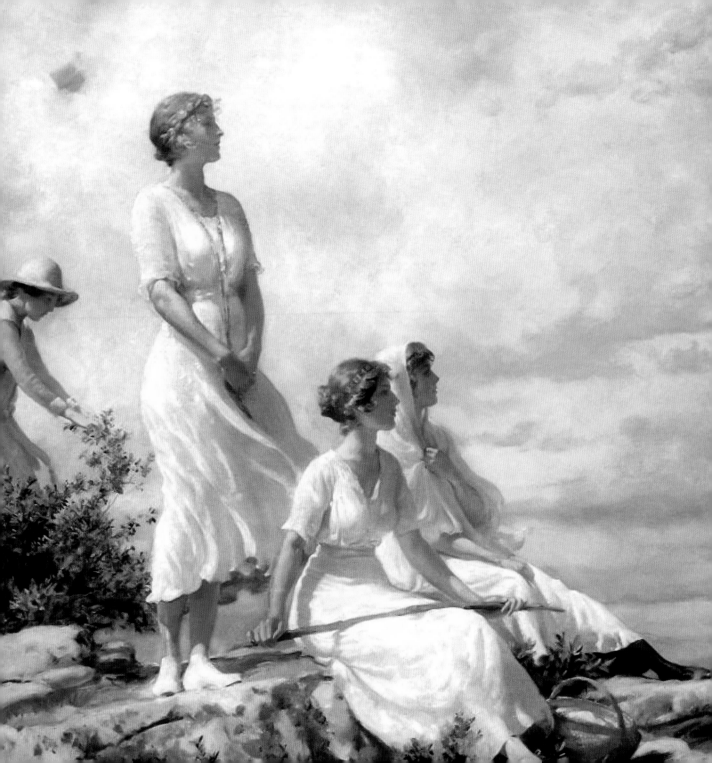

Charles Courtney Curran,
American, 1861–1942
Summer Clouds, 1917
Oil on canvas, 50 × 40 in.
Private collection

Setting Out

H aving climbed to the top of the cliff, with anticipation the young women gaze out at the landscape, or—we cannot know—at the sea and the spectacle of lovely summer clouds. Do the clouds suggest the uncertainty in the lives of these young women dressed in innocent white, who after their climb are to some extent looking into an unknown future and are setting out on their own?

In his genre scenes the American painter Charles Courtney Curran (1861–1942) favored young, slender female figures in romantic surroundings and wide, expansive landscapes, always with a particular focus on light effects.

Dangerous Thoughts

Dangerous thoughts could overcome women even on solitary walks in nature. It is therefore unsurprising that on walks by herself the scandal-ridden Emma Bovary sought to escape her passionless marriage:

🐦 She went as far as the beeches of Banneville, near the deserted pavilion which forms an angle of the wall on the side of the country. Amidst the vegetation of the ditch there are long reeds with leaves that cut you.

She began by looking round her to see if nothing had changed since last she had been there. She found again in the same places the foxgloves and wallflowers, the beds of nettles growing round the big stones, and the patches of lichen along the three windows, whose shutters, always closed, were rotting away on their rusty iron bars. Her thoughts, aimless at first, wandered at random, like her greyhound, who ran round and round in the fields, yelping after the yellow butterflies, chasing the shrewmice, or nibbling the poppies on the edge of a cornfield. Then gradually her ideas took definite shape, and, sitting on the grass that she dug up with little prods of her sunshade, Emma repeated to herself, "Good heavens! Why did I marry?"

She asked herself if by some other chance combination it would have not been possible to meet another man; and she tried to imagine what would have been these unrealised events, this different life, this unknown husband. All, surely, could not be like this one.

Gustave Flaubert, *Madame Bovary*, 1857

Edmund Blair Leighton, English, 1852–1922
Parting During the Walk, 1899
Oil on canvas, 13 × 9¾ in.
Manchester Art Gallery

Charles Wellington Furse,
English, 1868–1904
Diana of the Uplands, 1903/04
Oil on canvas, 93¼ × 70½ in.
London, Tate Gallery

Boundless Energy

~~~~~~~~~~~~~~~~~~~~~~~~~~~

Leashed energy wants to break free on a walk in the wild, wind-swept landscape of the English uplands. At first glance this would seem to be the message of this picture. But at the same time it is a brilliant portrayal of the personality of the subject, the painter's wife, Katharine Furse (1875–1952). In fact the staging of the portrait, well thought out, reflects the walker's relationship with her own nature. In this inhospitable, desolate, and deserted hilly landscape she wears an extravagant white satin coat. Greyhounds were favored by noblewomen, and symbolized ultimate refinement. Accompanied by these two—rented for the time it took to make the picture—she thus poses as a great woman, in what is in many respects a break with the standard "portrait of a lady."

Shortly after the picture was painted her husband died, and she was left alone with two sons. But with great self-confidence and independence she set out on a successful career of her own as a nurse, and would later serve as director of the Red Cross during the First World War. Having spent her childhood in the Swiss Alps, which according to her autobiography (*Hearts and Pomegranates*, 1940) she loved above all else, after the war she worked in Switzerland promoting tourism and Alpine sports, and for many years directed the World Association of Girl Guides and Girl Scouts. Thus the plein-air portrait of this venturesome woman in the wind proves to be a symbol of vitality, love of life, and female emancipation. It was no coincidence that Katharine Furse and Virginia Woolf were friends; their correspondence reflects the liberated, unconventional spirit of these two unusual women perfectly content to be on their own.

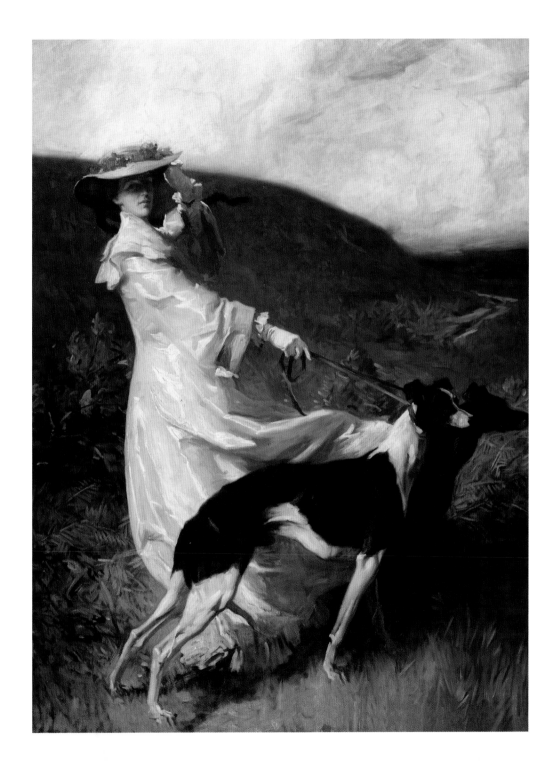

# 4. High Up: Above It All

*I had no desire to take the color out of my life through caution. . . . I do not regret having clung to this illusion for a long time, for to it I owe a boldness that made life easier.*

~~~~~~~~~~~~~~~~~~~~~~~~

Simone de Beauvoir, French, 1908–1986

Charles Courtney Curran,
American, 1861–1942
On a Hill, 1914
Oil on canvas, 25¼ × 22¼ in.
Private collection

Having achieved what you wished for, you will in any case miss one thing: the striving toward that end.

Marie von Ebner-Eschenbach, Austrian, 1830–1916

For centuries the Alps were considered inaccessible, only to be crossed on the road to Italy, famous for their difficulties and dangers. It was only in the 18th century, with the Enlightenment's new sense of nature, that their rugged peaks and deep gorges lost their mystery. The Alps came to be of interest to science, seen as the quintessence of primordial nature. Travelers on the Grand Tour set out to "conquer" the sublime mountain world on foot. Mont Blanc (15,774 feet) was first climbed in 1786.

Early on there were a few women among these mountain tourists, not on foot, to be sure, for that would have been unseemly. They had themselves carried up the mountains in frighteningly shaky wicker chairs, as reported by the English writer Mary Wortley Montagu (1689–1762) in 1718 and by the German woman of letters Sophie von La Roche (1730–1807) in 1784. Not only did they freeze from lack of movement, they feared plunging out of their litters into a chasm. Nonetheless, Sophie von La Roche described her encounter with the French peaks in 1784 as the most wonderful experience of her life.

At first mountain climbing was a man's business, and the high mountains were a male domain. The Alpine societies founded in the mid 19th century were initially open only to men.

But women did not allow themselves to be excluded for long, and began to tackle mountains on their own. Such notables as Queen Victoria (1819–1877), a passionate painter who portrayed Mount Rigi (5,900 feet) and the Pilatus (6,982 feet) during her sojourn in the Swiss mountains in 1865, Empress Elisabeth of Austria (1837–1898), and the Italian queen Margherita of Savoy, succumbed to their fascination. Among the first women scientists who devoted themselves to geological studies in the mountains were the British fossil collector Etheldred Benett (1776–1845) and the Scottish geologist and champion of women's rights Maria Matilda Ogilvie Gordon (1864–1939). It was still uncommon for women to scale

high peaks, for in the first decades of Alpinism, women on a mountain, even though accompanied by men, with male guides, or even worse alone or with only female companions, were thought scandalous. Even the local mountain women forced to take endless hikes as porters for mountain-climbing tourists were not considered capable of pioneering mountain tours and first ascents. Although in 1808 the Swiss peasant girl Marie Paradis (1778–1839) became the first woman to climb Mont Blanc, it was only in 1838 that the French noblewoman Henriette d'Angeville (1792–1871) attained fame as the "Bride of Mont Blanc" after effectively writing about her achievement.

The first female Alpinists at the end of the 18th century were generally seen with mistrust and belittled, as they seemed to represent a twofold threat. For one, they emancipated themselves with outstanding athletic achievements and thus entered into active competition with men. For another, in doing so they refuted traditional images of men and definitions of supposedly innate female behavior: that as the weaker sex they were incapable of major physical exertion. Requiring endurance, sure-footedness, and strength, mountain climbing, a fixed component of male initiation rites, could accordingly be mastered by women only against great resistance. The "wild" world of mountains seemed to be the realm of men, one that women might enter only as "unkempt hags in slatternly clothing," and in which they needlessly exposed themselves to unpredictable dangers.

The notion of mountains as the setting for erotic seduction, the imaginary topography of the Alps as a "chaste beauty" awaiting male conquest, contributed to the rejection of female efforts at inaccessible heights. So it is hardly surprising to find gender-specific terms in descriptions of unspoiled nature and references to climbs to celebrate a man's coming of age. Erotic speculations were accordingly also formulated by female mountain climbers, who in the company of male guides reached a peak experience only after intense exertions.

In the light of all this, it was no means easy for women to assert themselves as independent Alpinists. Unlike simple walks and shorter hikes, Alpine tours required proper equipment: from rugged shoes and walking sticks to trousers—unheard-of for ladies. So the first female mountain climbers set out in long skirts, but such cumbersome garments disappeared into their backpacks at the sight of the first ridge. The challenge

was to continue to be a lady even while mountain climbing, so clothing had to be both practical and still conform to the dictates of society.

The road to equal rights for women and their achievements in climbing 26,000-foot peaks was a long one. It took more than a century before a famous mountain climber like Reinhold Messner could write in his book about women climbers: "Women can not only withstand high altitudes better than men, they are also more elegant climbers."

Giovanni Segantini,
Italian, 1858–1899
Midday in the Alps, 1891
Oil on canvas, 30 ½ × 28 ¼ in.
St. Moritz, Segantini Museum

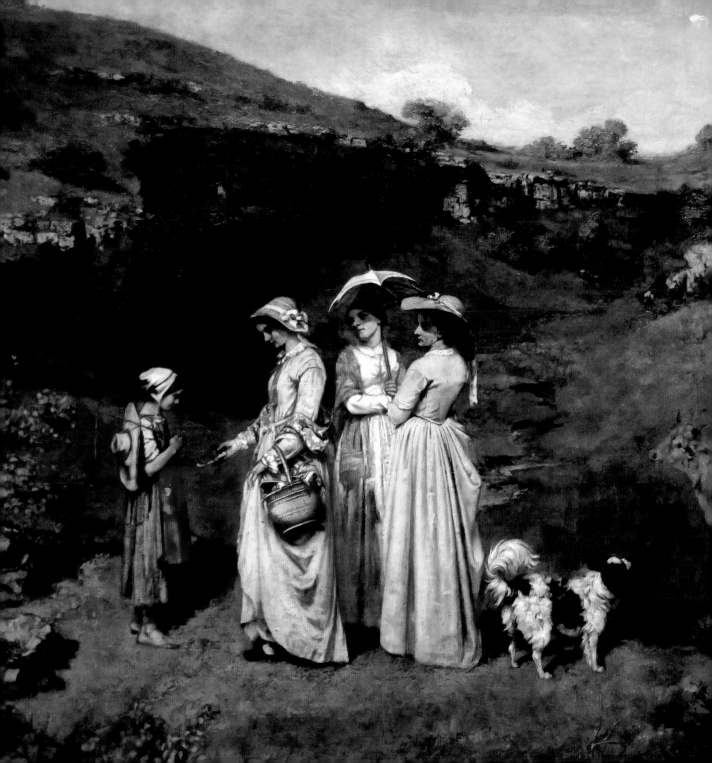

Gustave Courbet, French, 1819–1877
Young Ladies of the Village, 1851–52
Oil on canvas, 76 ¾ × 102 ¾ in.
New York, The Metropolitan
Museum of Art

Out for a Stroll

The controversial realist Gustave Courbet painted his three sisters, Zélie, Juliette, and Zoé, out for a stroll in the countryside, near the their home village of Ornans, in Eastern France. The distinctive limestone cliffs of the Jura Mountains are in the distance.

Perhaps surprising to the contemporary viewer, critics at the Paris Salon of 1852 were nearly universal in their disparagement of this work. They mentioned the scale of the cattle, the "ugliness" of the women, and—perhaps most revealingly, given the democratic uprisings in the French countryside in 1848—the whiff of class issues stirred up with the artist's use of the word *demoiselles* (young ladies) to describe the rural bourgeoisie.

Winslow Homer, American, 1836–1910
In the Mountains, 1877
Oil on canvas, 23⅞ × 38⅛ in.
New York, Brooklyn Museum

Plucky Hikers

Pictures like this showing independent, athletic women climbing a mountain without being accompanied by a man were still unusual in 1877. The steep climb demanded strength, endurance, and sure-footedness, considered male qualities and difficult to square with prevailing bourgeois notions of female abilities. By setting out into the mountains alone women conquered a world previously held to be the domain of men. And in doing so they entered into direct competition with men, provoking in them a degree of anxiety and insecurity.

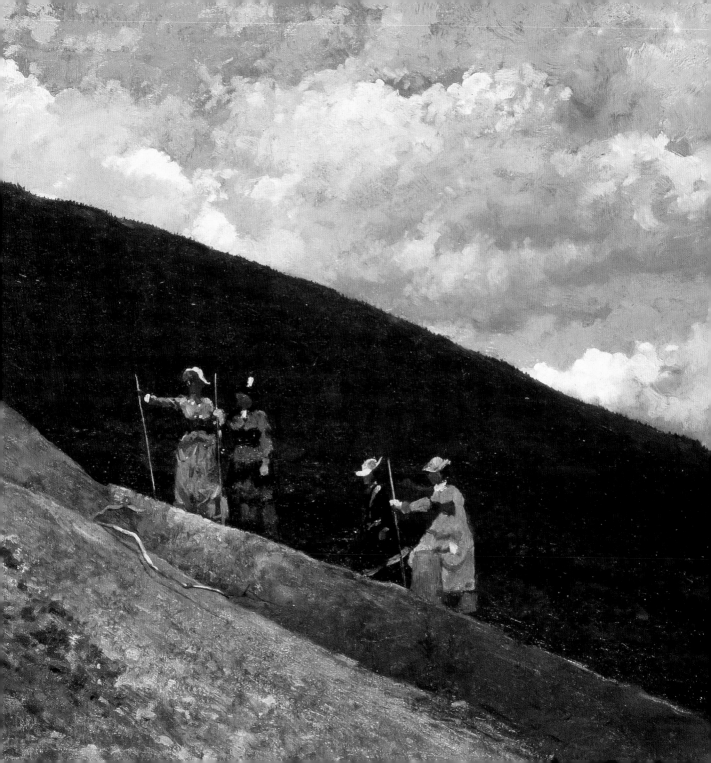

Hans Andreas Dahl, Norwegian, 1881–1919
Hiker Taking a Rest in Mountainous Land-scape, ca. 1900
Oil on canvas, 50 × 60 in.
Private collection

Far, Far Away

Isolated and remote from civilization, the mountain world is a place for contemplation and self-discovery, of freedom and emancipation, where "truth" comes to light. For here a woman liberated from social conventions can explore her own nature. It is no coincidence that mountains are symbols of borderline experience and transgression, even seduction.

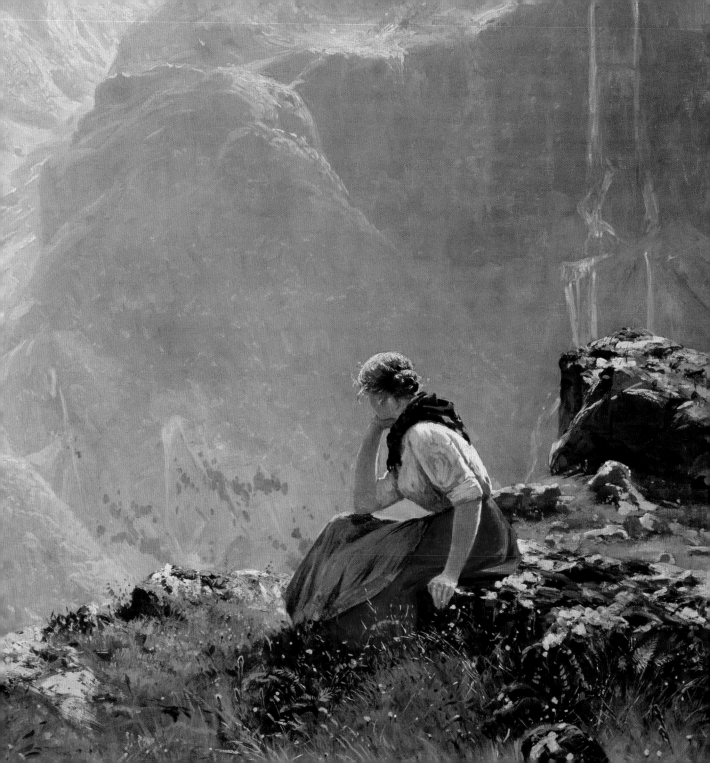

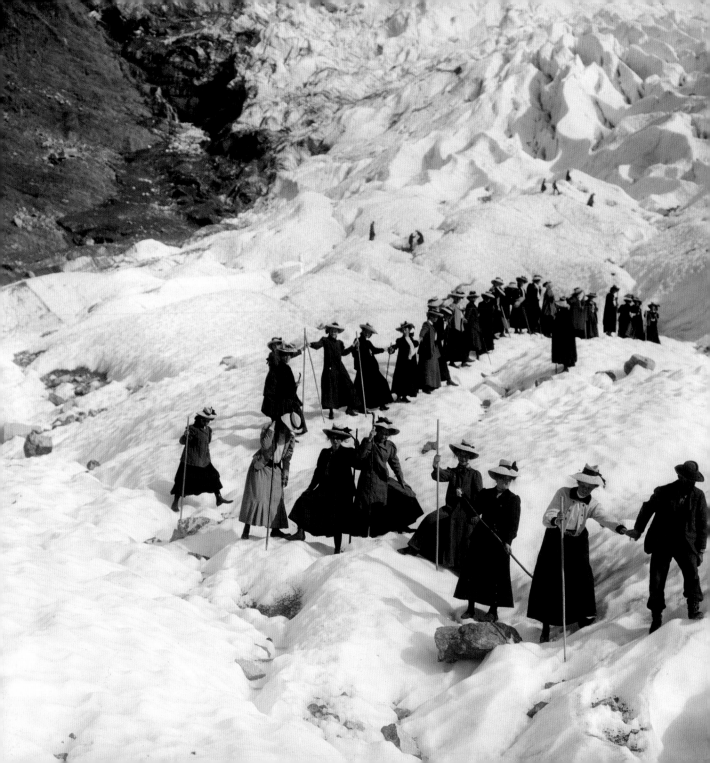

Tackling Mountains in Skirts

The conquest of Mont Blanc, first achieved by two climbers in 1786, was of great public interest in the 19th century, and therefore a challenge even to women like Henriette d'Angeville (1794–1871). The French noblewoman reached Europe's highest peak on her own in 1838, and wrote a report about her climb. She wished to show the world that women were perfectly capable of such feats and at the same time provide the general public with a feminine view of such an impressive experience in "untamed" nature. Her writing about what she experienced—the record of her expedition—contributed greatly to her fame. She described climbing as a test of will. This pioneer of women's Alpinism firmly adhered to the motto "What you want to do you can." Ultimately she made it clear that a woman is just as capable of living the dream of the modern explorer as a man.

Mont Blanc thus became a platform for female emancipation, as seen in this early-20th-century photograph by the Seeberger brothers Jules, Louis, and Henri.

James Walker Tucker, 1898–1972
Hiking, 1936
Oil on canvas, 20¼ × 23¾ in.
Newcastle-upon-Tyne, Laing Art Gallery

Perfectly Equipped

T hree fit, athletic young women are orienting themselves with their trail map. Wearing shorts, and without male companions, they are perfectly equipped for a tour of the English countryside, complete with backpacks, water bottles, even cooking utensils. They are wholly independent, making their way on their own.

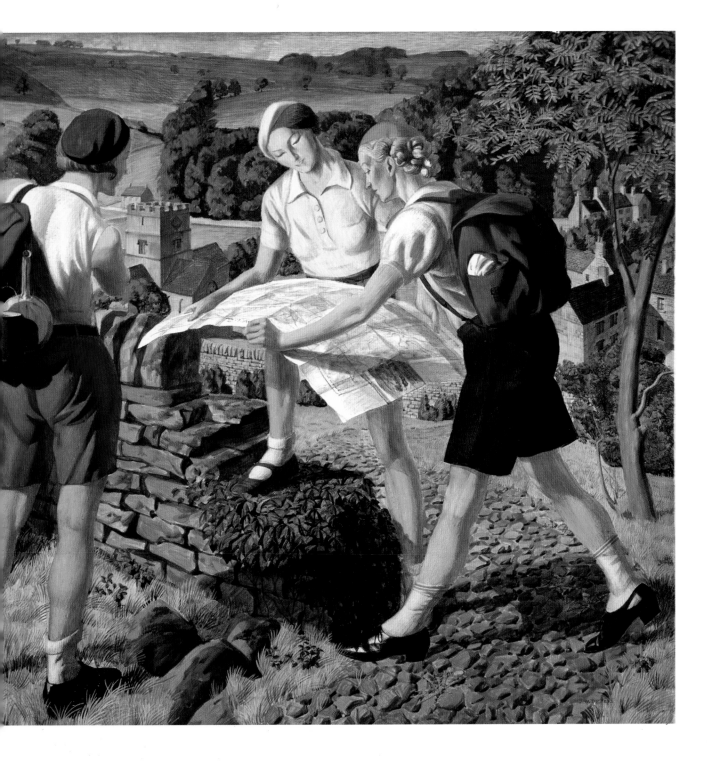

"Never again will I guide a woman up Mont Blanc"

᪥᪥᪥᪥᪥᪥᪥᪥᪥᪥᪥᪥᪥᪥᪥᪥᪥᪥᪥᪥᪥᪥

Following Marie Paradis, in 1838 the French mountain climber Henriette d'Angeville (1794–1871) was the second woman to stand on the peak of Mont Blanc, and is considered the first great female Alpinist. Marie Paradis had reached the top of Europe's tallest mountain in 1808, probably having been carried in spots by Jacques Balmat, who together with Michel-Gabriel Paccard had been in the first team to scale Mont Blanc, on August 8, 1786.

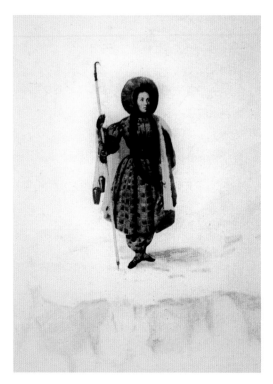

Henriette d'Angeville

At an early date Mademoiselle d'Angeville … undertook extensive mountain tours in her own district, on one occasion hiking a total of seventy hours in four days. It is difficult to believe, given her delicate frame and her small, elegant feet matched by lovely hands. But there is spirit and steadiness in her eyes, determination in her speech, and she demonstrates every social accomplishment. She is not pretty. At the time of her ascent (September 4, 1838) she had just turned 42.

Ten years before, on first seeing Mont Blanc aglow in the light of the setting sun, she had felt a powerful longing to stand on top of it, a feeling that she had nourished ever since. Since Mademoiselle d'Angeville is not wealthy, she worked for several years in order to save up the money needed for her climb, and finally said to herself: "Now I am going to do it." In early September she traveled from Geneva to Chamonix. There she immediately announced her intention. Everyone, even the guides, advised her against it.

But she would not be dissuaded, and she persisted in her resolve. So ultimately it was necessary to bend to her wishes and enter into negotiations with her. She engaged Joseph Coutet, who had already scaled Mont Blanc seven times, as her main guide, five additional guides, and two bearers. They were nine in all. When a clear sky and cool air promised a glorious day on September 3, a Monday, they prepared for their departure, putting their equipment, drinks, and food in order. She wore a skirt made of a thick, rough woolen fabric over warm leggings, and on top of it a goatskin cloak of the kind worn by local Alpine dairy maids, a fur bonnet pulled low onto her forehead, and a wide straw hat, but without a green veil, also no green glasses. In addition she wore strong shoes with gaiters and carried an alpenstock with a chamois horn. Without any difficulty or discomfort the valiant climber reached the Obelisk at the Grands Mulets, where she collected plants and wrote small notes to friends and relatives, enclosing souvenirs of the spot [. . . and the night's encampment was set up].

They started out again at around three. . . . While the guides ate breakfast, she changed clothes in the tent, leaving off her cumbersome skirt, and instead put on thick warm men's clothing. She climbed on with a light step that astonished her guides and led them to repeatedly exclaim that they had only rarely seen a man walk, climb, and jump across crevasses with such strength, assurance, and

determination. . . . Only after the Petits Mulets did Mademoiselle d'Angeville begin to tire, all the more so the closer she came to the Mur de la Cote. This is the last ledge that has to be climbed before reaching the top of Mont Blanc, but the most difficult one owing to its gradient of 80 to 82 degrees. All her guides were exhausted as well, with the exception of her main one, who continued to precede her and cut broad steps in the frozen snow with a small ax. The otherwise so bold and courageous lady now became increasingly dispirited, with a frightening feeling of tightness in her chest and as if molten lead were flowing in her veins. Several times she involuntarily sank down, and at one such moment—incapable of saying a word herself—she heard her guide exclaim: "Jamais je ne menerai plus de femme sur le Montblanc" ("Never again will I guide a woman up Mont Blanc"). . . . Fortunately, with his help her strength was sufficient for her to reach the top after incredible effort. Tuesday, September 4, at 12:55.

The moment the air of the peak filled her lungs she felt restored and strengthened, quite unlike all those male Mont Blanc climbers who have always reported being weak and washed out on the peak. She felt not only high and exalted, but also bodiless, serene, and gay.

Karl Josef Jurende, *Jurende's Moravian Wayfarer for the Year 1842* (*Jurende's Mährischer Wanderer für das Jahr 1842*)

A New Turn to My Career

❧❧❧❧❧❧❧❧❧❧❧❧

L ooking back, I feel that my arrival in Marseille marked a completely new turn to my career," Simone de Beauvoir (1908–1986) wrote in her autobiography, for there she discovered a nature that would, "little by little, become familiar to me—and perhaps give me greater familiarity with myself."

🐦 The passion [for walking] which caught hold of me then has persisted for over twenty years, and age alone has extinguished it. . . . There was nothing new or surprising about this. The countryside round Marseille was at once wild and easy of access . . . Such excursions formed the local inhabitants' favorite pastime. . . . I was exceptional in that I never attached myself to a group, and managed to turn a pastime into a most exacting duty. Between October 2 and July 14 I never once found myself wondering how to spend my Thursdays and Sundays. I made it a rule to be out of the house by dawn, winter and summer alike, and never to return before nightfall. I didn't bother with all the preliminaries, and never obtained the semiofficial rig of rucksack, studded shoes, rough skirt, and windbreaker. I would slip on an old dress and a pair of espadrilles, and take a few bananas and buns with me in a basket. Sometimes my friends would pass me in the hills, smiling disdainfully. On the other hand, with the aid of the Bulletin, the Guide Bleu, and a Michelin map, I used to work out my routes to the last detail. At first I limited myself to some five or six hours' walk-

ing; then I chose routes that would take nine to ten hours; in time I was doing over twenty-five miles in a day. I worked my way systematically through the entire area: I climbed every peak—Gardaban, Mont Aurélien, Mont Sainte-Victoire, and the Pilon du Roi—and clambered down every gully; I explored every valley, gorge, and defile. On I went, among those white and blinding stones, where there was not hint of path, watching out for the arrows—blue, green, red, or yellow— which led me on I knew not whither. Sometimes I lost track of them and had to hunt round in a circle, thrusting through sharp-scented bushes, scratching myself on various plants which were still new to me: resinaceous rock-roses, juniper, ilex, yellow and white asphodel. I followed all the coast guards' tracks, too; here, at the base of the cliffs, along this racked and indented coast line, the Mediterranean lacked that sweetly languorous calm which so often sickened me when I encountered it elsewhere. In morning splendor it surged fiercely against the headlands, dazzling white, and I felt that if I plunged my hand in I would have my fingers chopped off. It was splendid, too, to watch

from the clifftops while with deceptive ease and sheer solid inorganic power it smashed over the breakwaters protecting the olive trees. There came a day in spring, on the Valensole plateau, when I found almond trees in blossom for the first time. I walked along red-and-ocher lanes in the flat country near Aix-en-Provence, and recognized many of Cézanne's canvases. . . . I looked for a revelation from each successive hilltop or valley, and always the beauty of the landscape surpassed both my memories and my expectations. With tenacious perseverance I rediscovered my mission to rescue things from oblivion. Alone I walked the mists that hung over the summit of Sainte-Victoire, and strode along the ridge of the Pilon du Roi, bracing myself against a violent wind which sent my beret spinning down into the valley below. Alone again, I got lost in a mountain ravine on the Lubéron range. Such moments, with all their warmth, tenderness, and fury, belong to me and no one else. How I loved to walk through the town while it was still dark, half asleep, and see the dawn come up behind some unknown village! I would take a mid-day nap with the scent of broom and pine all around me; I would clamber up the flanks of hills and go plodding across open uplands, and things foreseen and unforeseeable would befall me on my way. I never lost the pleasure of finding a dot or some lines upon a map, or three lines entered in my Guide, transformed into stones, trees, sky, and water. . . .

Toward the end of November my sister [Hélène] arrived in Marseille, and I initiated her into these new pleasures of mine. . . . We saw the Roquefavour aqueduct under a bright midday sun, and ploughed through the snow round Toulon in espadrilles. My sister was un-used to such activities; she suffered from ago-nizing blisters, yet she never complained, and managed to keep up with me. . . .

The will power that manifested itself in these fanatical walking trips of mine was some-thing very deep-rooted. . . . I had never prac-ticed any sport, and therefore took all the more pleasure in driving my body to the very limit of its endurance . . . each expedition was a work of art in itself.

Simone de Beauvoir, *The Prime of Life*, 1960

Hélène and Simone de Beauvoir
Hiking, ca. 1931/32

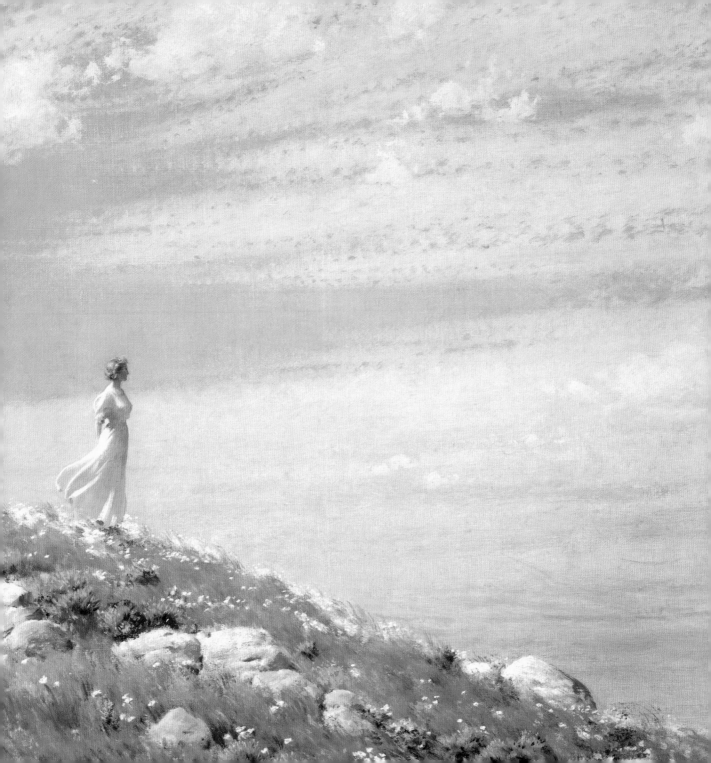

I'm happiest when most away
I can bear my soul from its home of clay
On a windy night when the moon is bright
And my eye can wander through worlds of light

When I am not and none beside
Nor earth nor sea nor cloudless sky
But only spirit wandering wide
Through infinite immensity

Emily Brontë, English, 1818–1848

Charles Courtney Curran,
American, 1861–1942
A Breezy Day, 1908
Oil on canvas, 30⅛ × 30⅛ in.
Private collection

Sources & Literature

INTRODUCTION

· Page 16 "Round this island": Elizabeth von Arnim, *The Adventures of Elizabeth in Rügen*, London 1904.
· Page 18 "full-time women writers": the 1823–25 lexikon *Die deutschen Schriftstellerinnen des neunzehnten Jahrhunderts* lists more than 500 women writers active between 1795 and 1825.
· Page 18 "Promenading in public places": Johanna Schopenhauer, *Jugendlieben und Wanderbilder*, Tübingen 1958, p. 141.
· Page 18 "selecting out-of-the-way footpaths": ibid.
· Page 21 "described . . . by Sophie von La Roche": Sophie von La Roche, *Geschichte des Fräuleins von Sternheim*, 1771, Stuttgart 1983, p. 84.
· Page 21 "The man who walks": Johann Gottfried Seume, "Mein Sommer 1805" [1806], in J. G. Seume, *Werke*, vol. 1, Frankfurt 1993, p. 543.
· Page 22 "Without being followed": Johanna Schopenhauer, *Jugendlieben und Wanderbilder*, 1839, Tübingen 1958, p. 141.
· Page 22 "This makes the testimony": Heidi Ritter, "Über Gehen, Spazieren und Wandern von Frauen in der zweiten Hälfte des 18. Jahrhunderts," in: Wolfgang Albrecht und Hans-Joachim Kertscher (eds.), *Wanderzwang—Wanderlust*, Tübingen 1999, pp. 91–105.
· Page 23 "Solitary walks": Jean-Jacques Rousseau, *The Confessions*, translated by W. Conyngham Mallory, online at https://ebooks.adelaide.edu.au/r/rousseau/jean_jacques/r864c.
· Page 24 "ideology of walking": Anne D. Wallace, *Walking . . . The Origins and Uses of the Peripatetic in the Nineteenth Century*, Oxford 1993, pp. 7f.
· Page 24 "virtually invisible counterpart": Aruna D'Souza and Tom McDonnough, *The Invisible Flâneuse? Gender, Public Space, and Visual Culture in Nineteenth-Century Paris*, Manchester 2006.
· Page 24 "only women of dubious reputation": Honoré de Balzac, *Histoire et physiologie des boulevards de Paris* (1845), Paris 1980, p. 92.
· Page 26 "What indelible joy it is": Honoré de Balzac, *Traité de la vie élégante* (1830).
· Page 27 "spirit of defiance": Ingrid Runggaldier, *Frauen im Aufstieg. Auf Spurensuche in der Alpingeschichte*, Bozen 2011.
· Page 27 "they are an offense to society": Caroline Fink and Karin Steinbach, *Erste am Seil, Pionierinnen in Fels und Eis. Wenn Frauen in den Bergen ihren eigenen Weg gehen*, Innsbruck 2013.
· Page 29 "I owe a supreme debt": Elizabeth Alice Burnaby-Main-Le Blond, *Day In, Day Out*, London 1928, p. 216.
· Page 32 "For her seemingly aimless London rambles": Virginia Woolf, "Street Haunting: A London Adventure" (1927), online at http://s.spachman.tripod.com/Woolf/streethaunting.htm.

· Page 32 "The best climber": Johanna Kinkel to Emilie von Henning, in: Fritz Böttger (ed.), *Frauen im Aufbruch. Frauenbriefe aus dem Vormärz und der Revolution von 1848*, Darmstadt/Neuwied 1979.

CHAPTER 1

· Page 35 "Promenading is an expression": Honoré de Balzac, "De la toilette dans toutes ses parties" (1830), in: *Pathologie de la vie sociale* (1839).
· Page 36 "No woman of the higher classes": Johanna Schopenhauer, *Jugendlieben und Wanderbilder*, 1839, Tübingen 1958, p. 141.
· Page 37 "Aristocratic strolls": Martina Trauschke (ed.), *Memoiren der Kurfürstin Sophie von Hannover. Ein höfisches Lebensbild aus dem 17. Jahrhundert*, Göttingen 2014.
· Page 38 "long since ceased": Markus Fauser, *Die Promenade als Kunstwerk. Karl Gottlob Schelles Theorie des Spaziergangs*, Leipzig 1803, p. 297.
· Page 43 "And here come these beaux": Edith Sitwell, *The English Eccentrics*, London 1933.
· Page 46 Paying One's Respects: Johann Adolf Ludwig Werner, *Weibliche Körperbildung für Gesundheit, Kraft und Anmuth*, Meissen 1834.
· Page 49 "18th-century writings and guidebooks": for example John Gay, *The Art of Walking through the Streets of London*, London 1716.
· Page 52 Decorum's Demands: Johann Adolf Ludwig Werner, *Weibliche Körperbildung für Gesundheit, Kraft und Anmuth*, Meissen 1834.
· Page 54: "She is holding a portable wooden camera": for this reference I am indebted to Dr. Ulrich Pohlman, curator of the photography collection at Munich's Stadtmuseum.
· Page 57 "A park is not a salon": Alfred Delvau, *Les Plaisirs de Paris: guide pratique et illustré*, Paris 1867, pp. 38f.
· Page 57 "at the onset of dusk": it was in fact decreed that prostitutes could appear on the streets only once the gas lamps had been lit.
· Page 60 "I often go walking": Marie de Rabutin-Chantal de Sévigné [Marie Marquise de Sévigné], *The Letters of Madame de Sévigné*.
· Page 63 Felix Vallotton, *La Vie meurtrière*, 1907/08

CHAPTER 2

· Page 65 "Unnoticed by painters": Ernest Chesneau, *Education de l'Artiste*, Paris 1880, p. 341.
· Page 66 "Villette is one blaze,": Charlotte Brontë, *Villette*.
· Page 67 "Accordingly, painters captured the city": Nancy Forgione, "Everyday Life in Motion: The Art of Walking in Late-Nineteenth-Century Paris," *The Art Bulletin* (December 1, 2005), pp. 663–87.
· Page 72 The Marvelous Art of Balanced Locomotion: Oliver Wendell Holmes, "The Physiology of Walking" (1859), in: *The Works of Oliver Wendell Holmes*, 13 vols., Boston and New York, 1892, vol. VIII, *Pages from an Old Volume of Life*, pp. 121–28.
· Page 76 What Good Form Prescribes: Constanze von Franken, *Katechismus des guten Tones und der feinen Sitte*, Leipzig 1890.
· Page 76 "Young women should always": Jane Austen, *Pride and Prejudice*.
· Page 80 "In the first winter": Ricarda Huch, *Frühling in der Schweiz* (1938), in: Wilhelm Emrich (ed.), *Ricarda Huch, Gesammelte Werke*, vol. 11, *Autobiographische Schriften, Nachlese, Register*, Cologne 1974.
· Page 81 An Irreplaceable Pleasure: Ricarda Huch, *Braunschweig in meiner Kinderzeit* (1949); *Frühling in*

der Schweiz (1938), in: Wilhelm Emrich (ed.), *Ricarda Huch, Gesammelte Werke*, vol. 11, *Autobiographische Schriften, Nachlese, Register*, Cologne 1974.

· Page 84 "These hours-long, brisk, and daily walks": Katherine C. Hill-Miller, *From the Lighthouse to Monk's House: A Guide to Virginia Woolf's Literary Landscapes*, London 2003.

· Pages 84–85 City Ramble with Virginia Woolf: Virginia Woolf, "Street Haunting: A London Adventure" London, 1927.

· Pages 88–89 "On the Kurfürstendamm": Irmgard Keun, *Das kunstseidene Mädchen*, 1932, Berlin 1979.

CHAPTER 3

· Page 91 "she went out sometimes": Gustave Flaubert, *Madame Bovary* (1857), translated by Eleanor Marx-Aveling, New York 1926.

· Page 92 "Elizabeth continued her walk alone": Jane Austen, *Pride and Prejudice* (1813).

· Page 93 "I once climbed a mountain": Franziska and Hermann Tiermann (eds.), *Meta Klopstock. Es sind wunderliche Dinger, meine Briefe. Briefwechsel mit Friedrich Gottlieb Klopstock und mit ihren Freunden, 1751–1758*, Munich 1988.

· Page 94 "combine in exciting ways the terror of heights": Alain Corbin, *Meereslust. Das Abendland und die Entdeckung der Küste*, Berlin 1990.

· Pages 100–101 "They passed through the forest": Dorothea Schlegel, *Florentin*, Lübeck and Leipzig 1801.

· Page 106 "Miraculous is the power": Friedrich Evertsbusch, *Lebensweihe für Jungfrauen. Anstandsbuch für junge weibliche Leser*, Elberfeld 1867, in: Dagmar-

Renate Eicke, *"Teenager" zu Kaisers Zeiten. Die "höhere" Tochter in Gesellschaft, Anstands- und Mädchenbüchern zwischen 1860 un 1900*, Marburg 1980.

· Page 107 Woman as Guardian of Morals: ibid.

· Page 113 Dangerous Thoughts: Gustave Flaubert, *Madame Bovary* (1857), translated by Eleanor Marx-Aveling, New York 1926.

· Page 114 Katherine Furse, *Hearts and Pomegranates*, London 1940.

CHAPTER 4

· Page 117 "I had no desire": Simone de Beauvoir, *The Prime of Life*, 1960.

· Page 118 "Having achieved what you wished for": Marie von Ebner-Eschenbach, *Aphorismen*, Berlin 1890.

· Page 120 "unkempt hags in slatternly clothing": Ingrid Runggaldier, *Frauen im Aufstieg. Auf Spurensuche in der Alpingeschichte*, Bozen 2011.

· Page 121 Reinhold Messner, *On top. Frauen ganz oben*, Munich 2010.

· Page 129 "wrote a report about her climb": Henriette d'Angeville, *Mon excursion au Mont-Blanc*, Paris 1987.

· Page 129 "What you want to do you can": ibid., p. 146.

· Pages 132–33 "Never again will I guide a woman up Mont Blanc": Karl Josef Jurende, *Jurende's Mährischer Wanderer für das Jahr 1842*, Brno 1841.

· Pages 134–35 "A new turn": Simone de Beauvoir, *The Prime of Life*, translated by Peter Green, Cleveland and New York 1960.

· Page 137 "I'm happiest": Emily Brontë, *The Complete Poems*, Penguin Books, London and New York 1992.

Picture Credits

Front cover: Bridgeman Images: Josef Mensing Gallery, Hamm-Rhynern, Germany.

Back cover: The Tate Gallery, London.

Interior pages: Akg-images: pp. 2, 20 IAM, 39, 40–41, 42, 48–49, 50–51, 55. Rabatti-Domingie: pp. 6–7 Album / Prisma, 10–11, 62–63, 69, 70, 77 Erich Lessing, 78 © Sotheby's, 87 Cameraphoto, 90 © Sotheby's, 95, 98, 100, 102, 104, 122 Album / Prisma, 124–125 De Agostini Picture Library, 126–127 © Sotheby's, 142–143, 146–147 © Sotheby's, 150–151. Alpines Museum des Deutschen Alpenvereins, Munich: 33. Bpk: pp. 96–97 RMN – Grand Palais / Michel Urtado, 127 RMN – Grand Palais / Frèrer Séeberger. Bridgeman Images: pp. 4–5 Musée d'Art Moderne et d'Art Contemporain, Liège, Belgium, 8–9 Museum of Fine Arts, Boston, Massachusetts / Peter Chardon Brooks Memorial Collection, Gift of Mrs. Richard M. Saltonstall, 19 Musée Hyacinthe Rigaud, Pergignan, 21 Museum of Fine Arts, Boston, Massachusetts / Peter Chardon Brooks Memorial Collection, Gift of Mrs. Richard M. Saltonstall, 23 photo © Peter Nahum at The Leicester Galleries, London, 25 Musée de la Ville de Paris, Musée Carnavalet, Paris, 30–31 Josef Mensing Gallery, Hamm-Rhynern, Germany, 47 Museum of Fine Arts, Boston, Massachusetts / The Elizabeth Day McCormick collection, 56 photo © Christie's Images, 58–59 © Christopher Wood Gallery, London, 61 © John Davies Fine Paintings, 74, 83 Sterling and Francine Clark Art Institute, Williamstown, Massachusetts, 110, 112 Manchester art Gallery, 116, 130–131 Laing Art Gallery, Newcastle-upon-Tyne / © Tyne & Wear Archives & Museums, 136 photo © Christie's Images, 152 Laing Art Gallery, Newcastle-upon-Tyne / © Tyne & Wear Archives & Museums. Fashion Design 1800–1940, Amsterdam 2004: p. 53. The Frick Collection: pp. 34, 148–149. Gandalf's Gallery: p. 64, 144–145. Galerie Hammer, Regensburg, Germany: p. 135. Drawing by Jules Hébert: p. 132. Adrian Michael: p. 121. Beverly Shipko: p. 14. The Tate Gallery, London: p. 115.

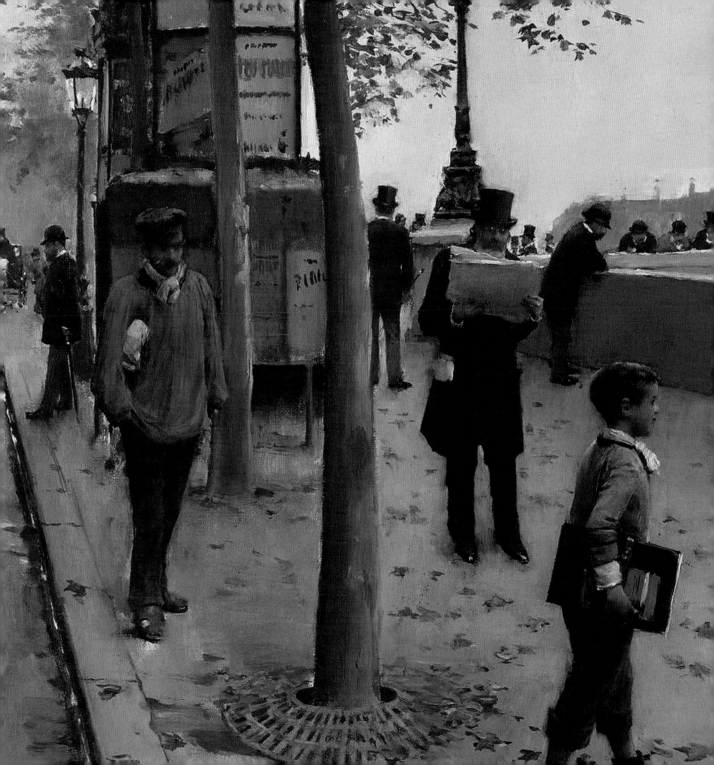

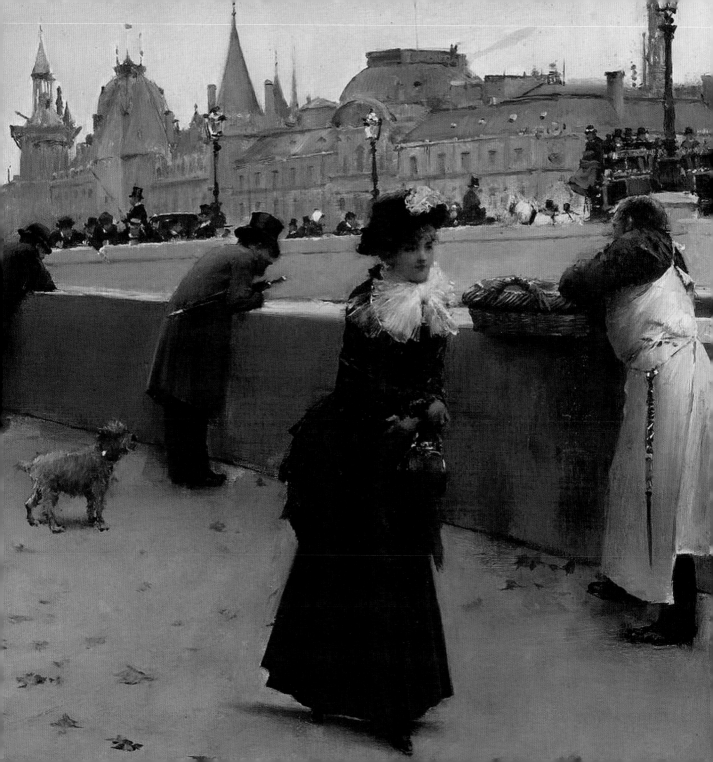

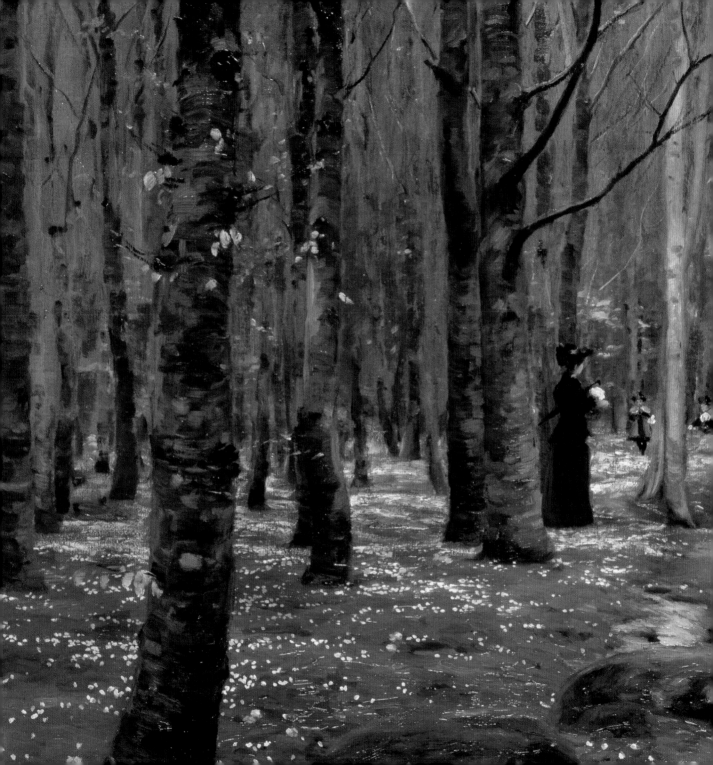

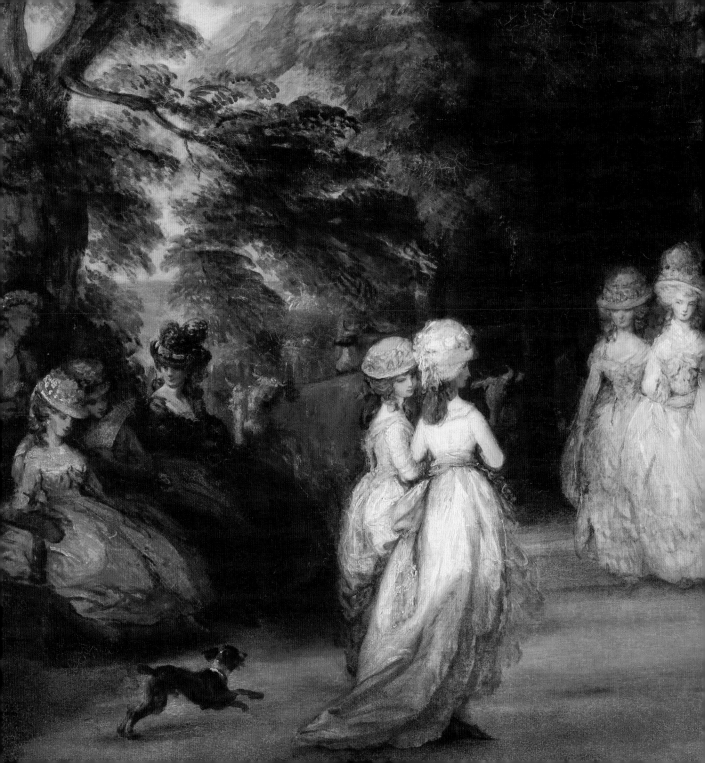

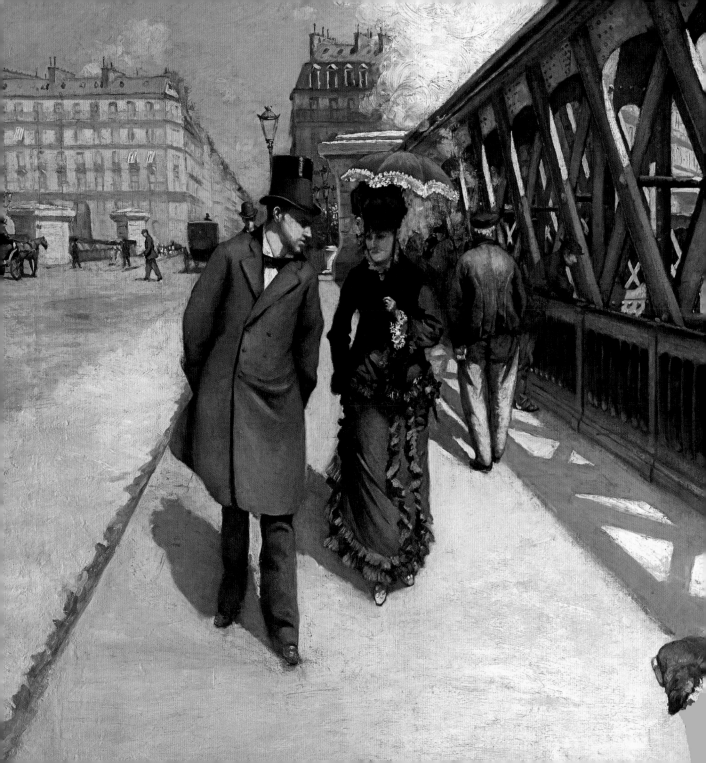

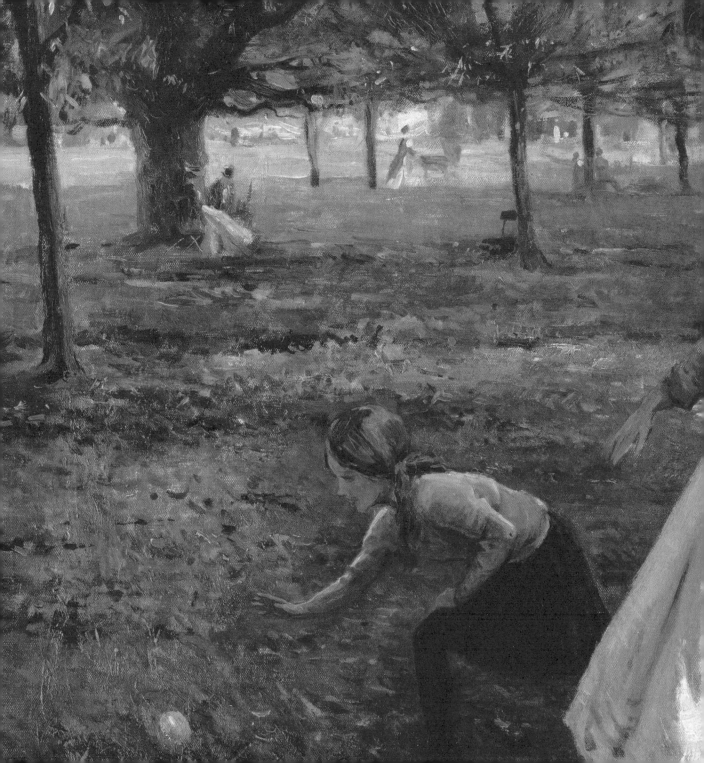